THORNTON
THROUGH TIME
Alan Whitworth

AMBERLEY PUBLISHING

I should like to dedicate this book to family and friends in Thornton;
David, Geraldine, Sonia and Mia, my son John and daughter Susanna
and their late uncle, Arthur Saul, Conservation Officer, Bradford MDC
whose regard for the village sparked my interest. 'Never Forgotten.'

First published 2011

Amberley Publishing
The Hill, Stroud
Gloucestershire, GL5 4EP

www.amberley-books.com

Copyright © Alan Whitworth, 2011

The right of Alan Whitworth to be identified as the
Author of this work has been asserted in accordance
with the Copyrights, Designs and Patents Act 1988.

ISBN 978 1 4456 0628 6

British Library Cataloguing in Publication Data.
A catalogue record for this book is available from
the British Library.

Typeset in 9.5pt on 12pt Celeste.
Typesetting by Amberley Publishing.
Printed in the UK.

Introduction

To many, particularly devotees of the Brontës, the name Thornton will be well-known, as it was here, in the year 1815 that the Revd Patrick Brontë took up his clerical duties with a wife and two young children before he moved to a final incumbency at Haworth. Yet in that brief period at Thornton, with the birth of Charlotte, Branwell, Emily and Anne, the foundation of a literary phenomenon was laid that has, in time, brought fame to the area – but the story of Thornton does not just begin at this point.

The origins of the village go back to before the Norman Conquest, when Thornton belonged to the manor of Bolton. It is spelt in the *Domesday Book* as 'Torenton' meaning 'enclosure of Thorns', but it is possible that the district had been settled prior to the ninth century as a number of funeral urns have been excavated over the years at Thornton and in the immediate vicinity.

According to John James, a noted local historian, as early as 1150 a family by the name of Thornton held large possessions here, the first notable lord being Hugh de Thornton. The Bollings of *Bolling Hall* were descendants of the Thorntons, and after them the manor passed by marriage to Sir Richard Tempest of Bracewell (Lancs.) until 1620. Around 1638, the manor was sold yet again, returning to local ownership by being bought by the Midgley family, and through them it was retained until 1715, when it was conveyed by Josiah Midgley – along with the Headley estate and Hall where he resided – to John Cockcroft, Attorney of Bradford.

While Thornton was in the possession of the Tempest family, a medieval deer park was formed. The park, which survives under the name Doe Park, now a reservoir from which Bradford derives part of its water supply, encompassed several miles and was well stocked with red deer for hunting. A considerable part of the park wall existed well into the twentieth century. Following the Enclosure Acts, and the walling of the moors and wastelands of Thornton in 1771, the manor was effectively dispersed.

The amount and type of land enclosed under the aforementioned Acts – over 900 acres of moor alone – gives a certain substance to the many writers' comments that Thornton was a 'wild, bleak and desolate' spot up until the early nineteenth century. An entry in the Bradford parish church registers, dated 23 December 1630, records 'a poor stranger found dead on ye moor in Thornton', revealing how treacherous the district could really be.

In the mid-1800s, Thornton saw development. The National School on the north side of the Market Street was built in 1831. The present St James's church was built in 1872 to replace an older edifice. Thornton Mechanics' Institute was conceived in 1835; a building was constructed in 1870. The Local Board was first elected in 1865. Gas was supplied into the area by the Clayton, Allerton & Thornton Gas Company and the Thornton branch of the Bradford, Halifax & Keighley Railway was started on 11 March 1874 and opened in 1878. This later led to the erection of one of the most outstanding features of the Pinch Beck Valley at Alderscholes, the 120-foot-high, twenty-arch railway viaduct.

It was at this time that the textile trade, with its roots in the previous centuries, was consolidated, and between 1826 and 1870 a number of mills were built in and around Thornton, notably Upper Mill, Dole and Prospect Mills. The stone trade was also an important element of the district. The original sandstone quarries were only small, and known locally as 'delfts', but large commercial quarrying was established in the early nineteenth century and tiny communities sprang up as a result at Moscow, Paris and later Egypt. In the 1870s, thirty quarries were recorded. There were collieries too, and alongside this seam of coal ran a good band of fireclay. During the period of 1870 to 1880, a fireclay trade of some size was established at Thornton.

Yet for all that, despite incorporation with Bradford in 1899 and steady growth since, Thornton has managed to retain an air of remoteness, and is still in principle a village community, self-sufficient and almost scornful of the twenty-first-century City of Bradford on its doorstep.

Indeed, it would be tricky trying to gain entrance to this field – an example of typical Thornton humour, stating the obvious!

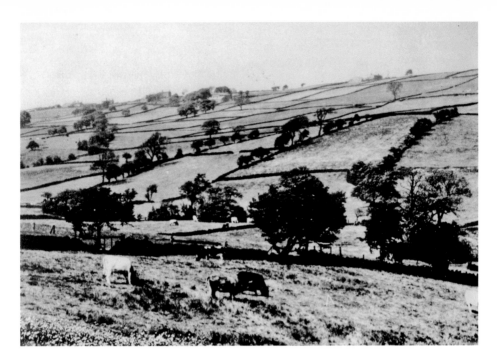

A Prospect of Headley

The origins of Thornton began with Headley, lying in the Pinchbeck Valley around three miles outside Bradford. It was here that prehistoric man first settled, and evidence of his existence has been found here including beakers and burial remains. Later there is suggestion of a castle on a prominence at Headley (*below*); but whether we are talking prehistoric earthworks or early medieval fortifications is unclear, as no archaeological work has ever been undertaken despite all these tantalising clues.

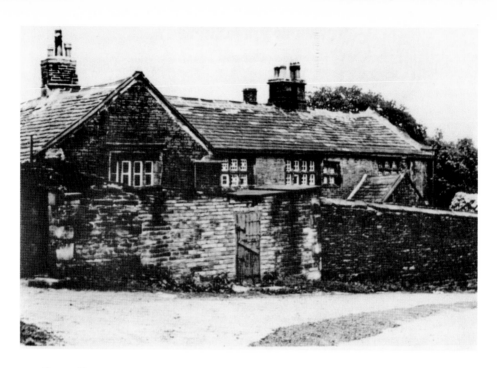

Headley Hall, Thornton

When Thornton was young, Nostell Priory had land in Headley during the thirteenth century. The house itself, Headley Hall, was erected by the Midgley family, lords of the manor in the seventeenth century, who had been resident here long before. In the west wing is an inscription which states 'W. Midgley, 1589'. A later inscription, 'JM 1604', over the porch possibly reflects building enlargements of the period. There is still much old woodwork, particularly in the upper rooms where many are panelled with oak wainscoting.

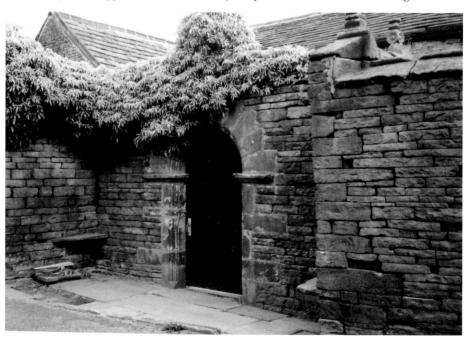

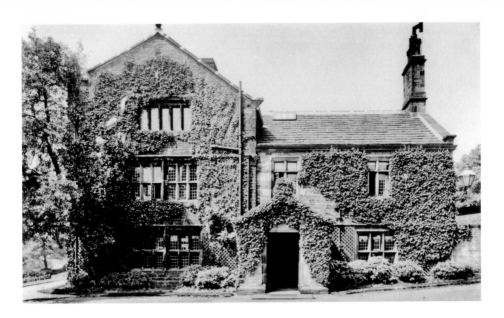

Thornton Hall

The fountain head of Thornton, the present Thornton Hall, hidden from view behind the ruins of the 'old bell chapel' is of seventeenth century date, but its origins undoubtedly go back into antiquity. This was the manor house, possibly a residence of the Thornton family who held lands here in 1230. The first Hall would probably have been a timber-framed building. In 1566, Richard Tempest was described in an Inquestion Post Mortem as 'of Thornton Hall in Bradford dale'. In 1608, the Burial Registers record 'Robert, son of Michael Burraye, Thornton Hall'.

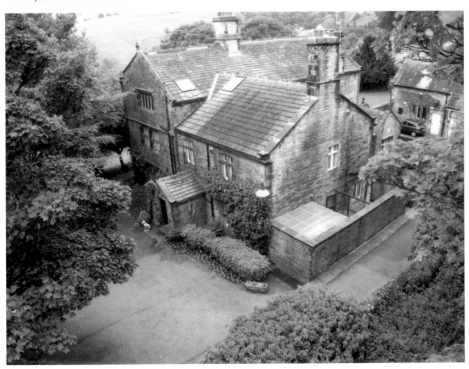

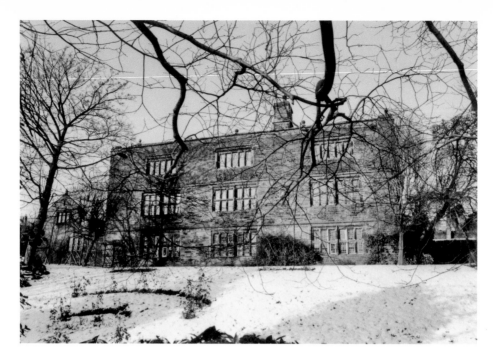

Thornton Hall from the South

In 1620, Thornton Hall was owned by William Illingworth, a miller. By the eighteenth century it had been divided, and in one part, in 1822, lived the church clerk and sexton. A pleasing feature is the old sundial of 1778 on an outside wall, which came from the church that sits adjacent. At one time a gate led from the churchyard into the hall grounds. A recent owner has had his coat of arms affixed to the gates below; however, it was not possible to ask after these.

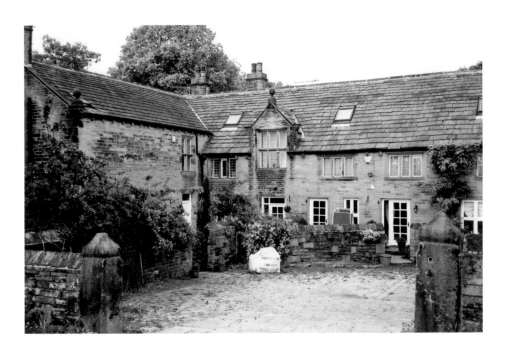

Thornton Hall Farm

Thornton Hall Farm is a substantial property dating back to the seventeenth century, but the present façade owes its origins to the rebuilding of the Foster family of Black Dyke Mills, Queensbury, who had ownership for a period. When I lived at Thornton it was occupied by Mr and Mrs Brown, a lovely old couple in their eighties who still rose each morning to milk the dairy herd. They introduced me to the delights of the garden, where masonry from the old Bell Chapel was carefully built up into an ornamental feature.

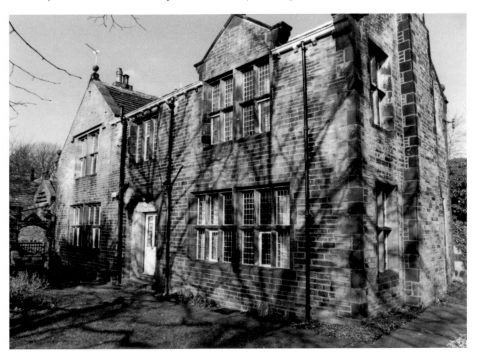

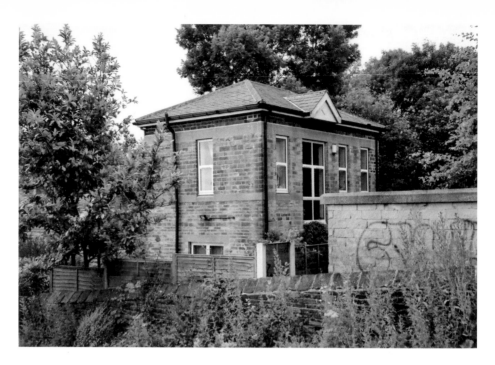

New Uses for Old Buildings

On entering Thornton from Bradford up the main highway there is a private un-adopted road on the left that leads to Thornton Hall and on the corner stood an electricity substation that has now been converted to house (*above*). The old Thornton swimming baths nearby have likewise been converted to apartments. Thornton Baths were, in 1931, said to be 'near completion' and they were opened the following year. Interestingly, it was provided with a moveable floor to cover the pool so that it could be used for other functions.

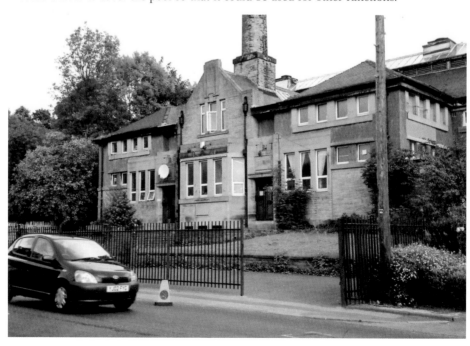

Kipping Barn and Kipping Lane
During the seventeenth century
persecution of Catholics and
Non-conformists, a small group met
here in Kipping barn in secret under the
leadership of Dr John Hall, of Kipping.
In 1672, a licence was granted for 'a room
or rooms in the house of John Hall, near
Thornton, to be placed for the use of
such who do not conform to the Church
of England, and are of the persuasion
called Congregational'. Accepted Lister,
a popular and influential elder, often
preached here.

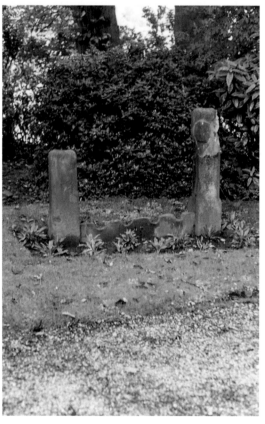

Kipping Lane and the Old Stocks
It is said Kipping is derived from the Latin *Kippus*, meaning 'keep' – an old name for the village stocks – and 'ing' or meadow – where the stocks were sited. The old stone stocks of Thornton are preserved in the grounds of Thornton Hall and consist of two stone uprights. There is evidence the taller was used as a whipping post. The date 1673 is inscribed on the outer face. One bottom rail survives, and has four leg-holes to hold two culprits, with two holes where staples were inserted to hold the top section.

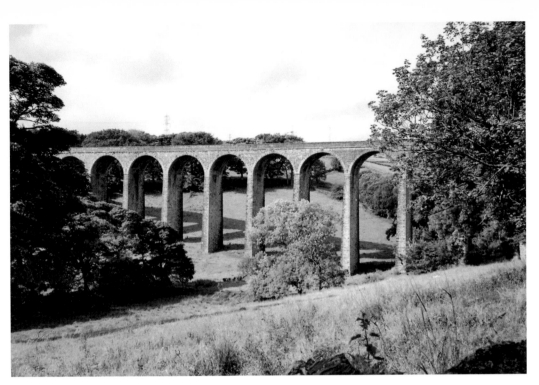

Thornton Railway Viaduct and Alderscholes

Erected during the mid-1870s, Thornton viaduct is 300 yards long and stands 120 feet from the valley floor at its maximum height. Built of brick and stone quarried locally, the central piers were sunk twenty-five feet underground to the foundations. Each of its twenty arches has a forty-foot span. The viaduct was constructed under the supervision of John Rowlands, from Tenby in North Wales. Rowlands later settled in Thornton, and is buried in the churchyard of the Bell Chapel. His relatives still resided in the district in 1984.

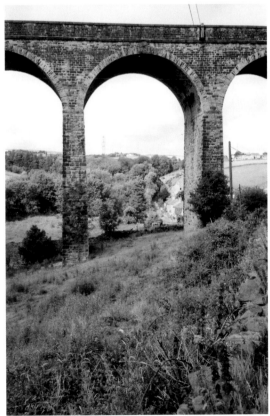

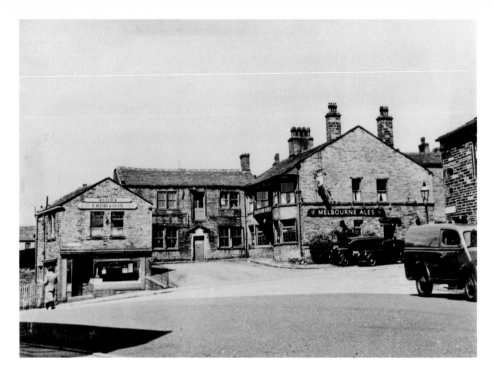

Black Horse Inn, Market Street

The Black Horse public house was second only to the Bull's Head in antiquity. In 1866, Joshua Bennett was landlord; however, the pub's origins went back considerably farther and in 1822 a 'Money Club' was held at the house of Mr J. Pickles, Black Horse Inn. The local tavern was often the natural meeting place to conduct village business and was more than just a drinking establishment. From this point commenced Kipping Lane, leading into Lower Kipping Lane. However, the new road cut it in two.

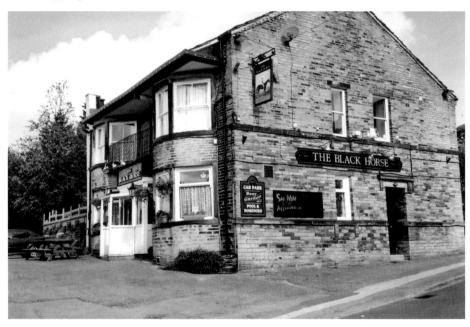

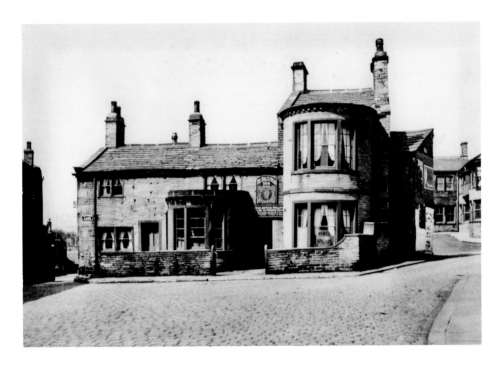

Bull's Head, Kipping Lane and Market Street

Standing detached and facing onto Market Street, it is said the inn was built on a piece of waste ground by a man named Thwaite, whose brother was a highway surveyor. A fine frontage of eighteenth-century date may have originated as early as the seventeenth century. In 1866 it was run by Sarah Pearson, who also had charge of the Wellington Inn and the Rock & Heifer! But by 1872, it was under the ownership of Matthew Haygarth. Sadly, in the late 1920s it was reduced to a ruin soon to be demolished.

Market Street towards Hill Top and West Lane

Thornton is a township in the parish of Bradford, and is situated about five miles from that town in the Poor Law Union of North Brierley. At the census of 1801 the population of the township was 2,474; in 1811, it was 3,016; in 1821, 4,100; in 1831, 5,968; in 1841, 6,788; and in 1851, it was 8,051. The number of houses in 1841 was 1,491; and in 1851, 1,577. In June 1853 according to a return prepared by the Assistant Overseer, the total number of houses was 1,688.

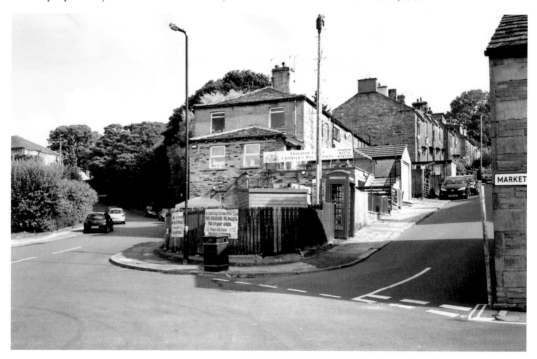

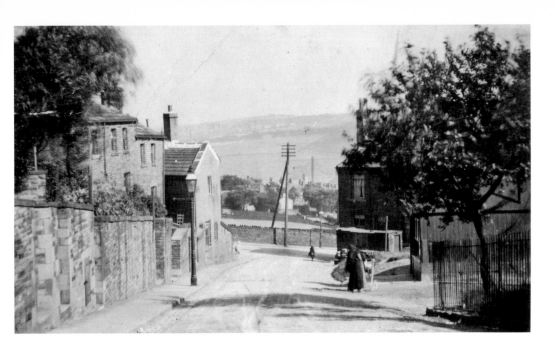

Roundfield Place, Hill Top

Connecting Thornton centre with Hill Top, an almost isolated hamlet of which it is recorded that often residents fought with those from the lower village. West Lane served a number of mills, notably Upper Mill, which today has been absorbed into Downs Coulters mill complex. The old cottages (*middle left*) have since been demolished, as have the mills. To the immediate left a close inspection reveals an opening in the wall. It was through this and up a dozen steps that led to my wife's parents' house, No. 10 Hill Top.

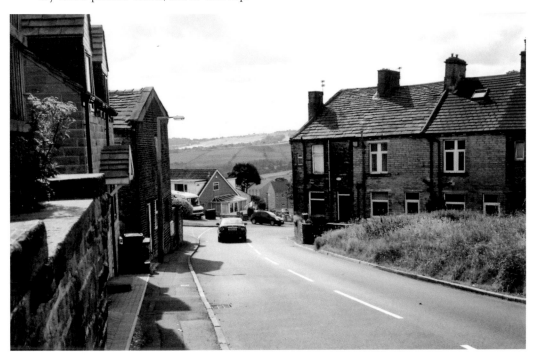

Hill Top, Thornton

In 1853, a survey on the conditions of housing at Hill Top recorded, 'New row, eleven houses, one pump, two privies in the middle, and in front of the doors; drains parallel with the houses here ... There are stone sinks, or troughs into which the people pour the filth ... In some cases, however, they pour it through a hole in the wall of a field, where it goes anywhere. In very numerous instances it is just poured out on the public road, where it stagnates and evaporates'.

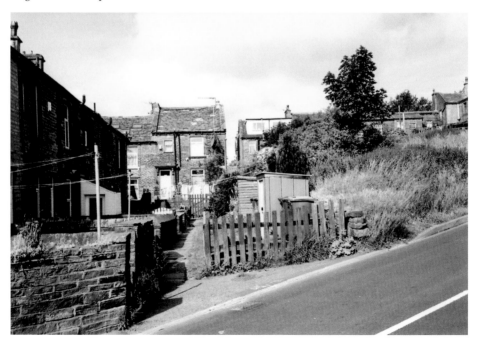

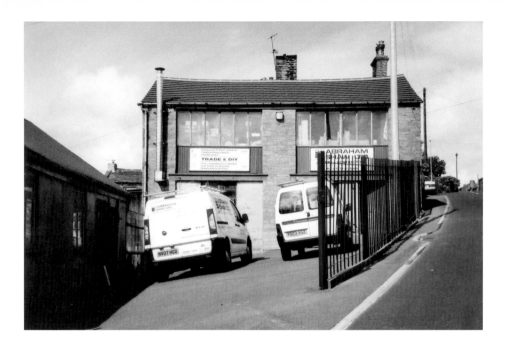

Abraham Shaw, Joiners, Hill Top

It is interesting how we can take things for granted. For years I saw these premises regularly, as my wife's family lived across from Abraham Shaw's joinery shop. Indeed, I have even bought wood from them. Having written three books about Thornton history and opened a local village museum I thought I knew everything about this place, but it was only when taking photographs for this book that I found out the building was originally erected as the 'Stronger Mission Church' and the foundation stone 'was laid by Mrs Theo Peel, 9 July 1892'.

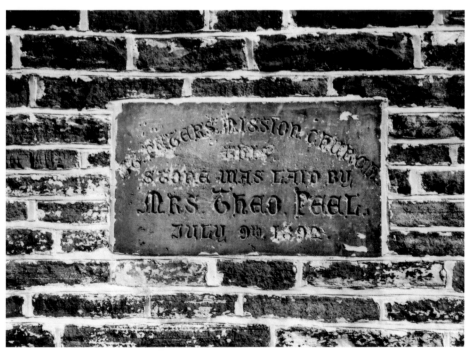

Sun Inn, West Lane

I was saddened to see the Sun Inn is now closed, as I drank here regularly. In 1872, the following Thornton ale houses were noted: Ashfield Inn, Sportsman's Inn, Springhead, New Inn, Bull's Head (run by Sarah Greenwood in 1866); Rock & Heifer (whose name reflects two major industries of the period carried on hereabouts); Black Horse Inn, White Horse Inn, Green Mount, Wellington and, after 1872, came the Sun Inn and the Cavalry Inn, and later still the Hill Top Public House below, which, despite its appearance, is now closed.

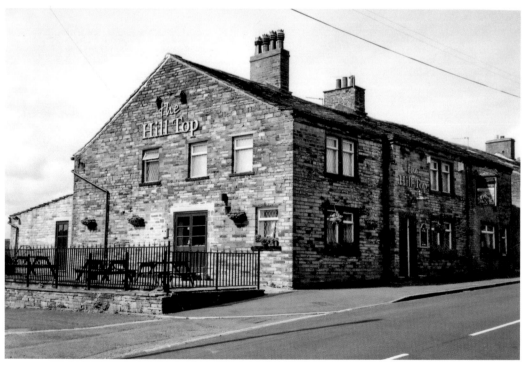

Hill Top Recreation Field

In March 1894, a recreation ground at Hill Top was opened to the public. The cost of laying it out and building a boundary wall, entrances, etc was £1,482. In area it contained over four acres. It was here, no doubt, that the local football teams, like the Church of England club below, would play. By 1931, land adjoining the Allotment Gardens at Thornton – in an area covering over two acres – was laid out as a Bowling Green, three hard tennis courts, and a children's playing area was provided on land at Royd Street.

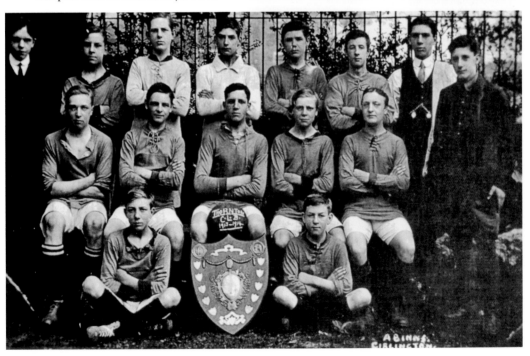

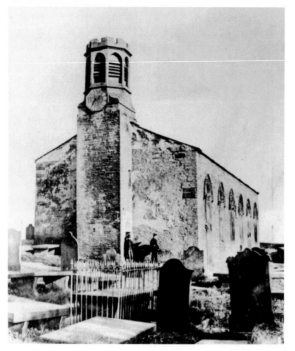

Thornton, St James's
As seen here, the old chapel of St James, left, whose ruins stand in the redundant graveyard across from the present parish church of Thornton, represents the tireless zeal and enterprise of the Revd Patrick Brontë, and following restoration, a dated wooden board on the exterior bore witness to this fact; it read, 'This Chapel was Repaired and Beautified 1818. P. Brontë, incumbent'. His 'repairs' entailed the demolition and rebuilding of the south wall with the insertion of spacious windows, the complete re-roofing of the church.

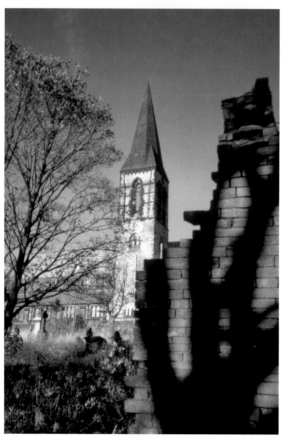

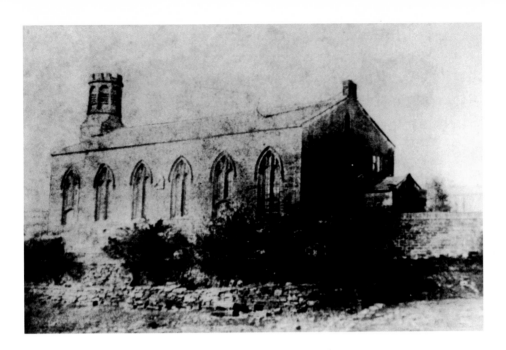

The Old Bell Chapel Interior

Prior to alteration 'inside the building it was damp, dark and extremely dismal; two galleries all but blocked out the light emitted by the small square windows ... having no organ, the singers and fiddlers performed from the east gallery. Fearing its structure unsound, Patrick had them brought down'. Even after Patrick Brontë's restoration, in 1888 Erskine Stuart described the building as 'mean looking ... with an unambitious cupola. It is in the Gothic style, but so bare and unpretentious, as to appear like an old dissenting meeting-house'.

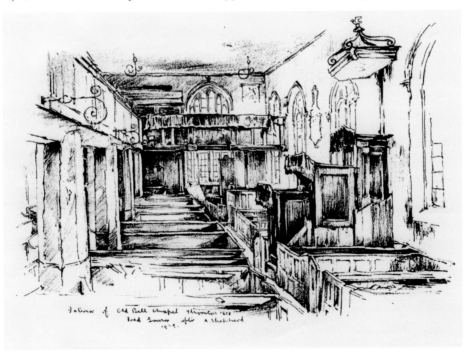

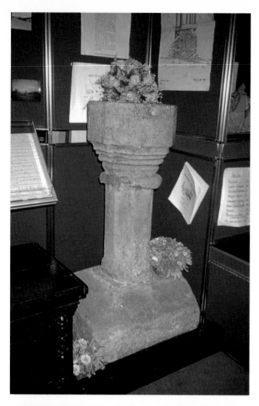

The Old Font, Thornton

Today, of the building in which the Brontë
family worshipped, a few artefacts can
be seen in the new church of St James's
across the road from the churchyard, in a
small museum corner; a holy water-stoup
of 1687, inscribed with the names of the
churchwardens (*top*), an old chest dated
1685, and a font (*bottom*) carrying the Latin
inscription '*Aqua Perficit Adla Vacrum
AD 1679*', which loosely translated means
'Through Water All are Made Free'. All of
the Brontë children were baptised here using
the ancient font from a previous church.
Later, in my time, a considerable amount
of stonework from the dismantled edifice
was rediscovered built into a garden wall
in the grounds of the adjoining Thornton
Hall Farm, including medieval sculptured
pieces from an earlier church, and a curious
hexagonal window with mason's marks
that cannot be seen in old illustrations so
historians are unsure of their origin.

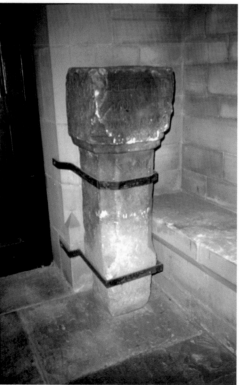

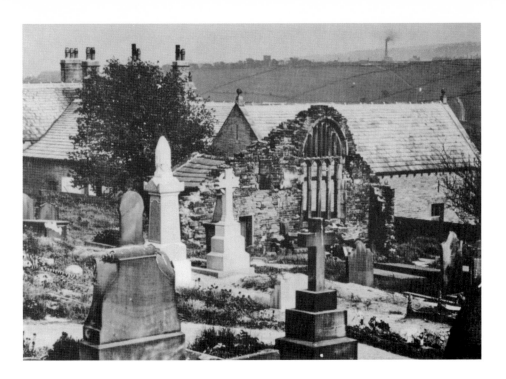

Thornton, St James's

The Revd Brontë in his restoration had erected an octagonal cupola and had the 'old' bell replaced inside – both of which gave the edifice the local name of 'owd bell chapel'. The remaining east wall has a number of inscribed dates and inscription in the masonry from earlier churches dating from 1587, 1612 and 1756. After a campaign by SPEC, the ruins of the old Bell Chapel are now a Grade II listed building and have been landscaped in recent years for the village to enjoy as a public amenity.

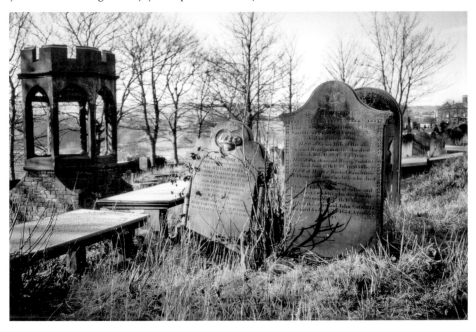

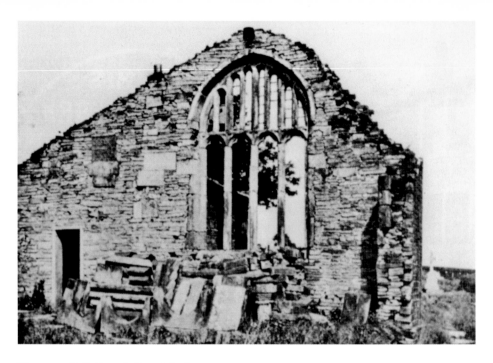

Thornton Bell Chapel, East Window

Of the second chapel there remains only the impressive east window of the ruins with carved portraits of the donors' heads charmingly displayed (*p. 27*). When the ruins were consolidated in the nineteenth century, it appears that the east window was reduced in height. Further than the east window, little is left of the early churches at Thornton, but historically, it was probably during the existence of this building that the dedication was changed to St James from St Leonard as recorded in a document dated 1560.

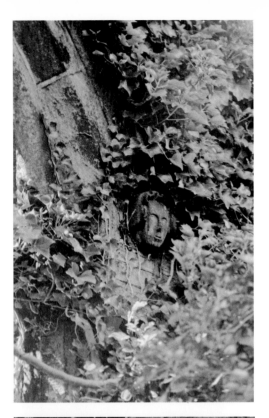

Thornton Bell Chapel, Datestones

The ruins display a number of early date stones and a carved inscription that reads, 'This Chappell was Builded by IIII-E, Freemason in the Yeare of Our Lorde 1612'. After extensive research, there is little doubt that the original foundation is of thirteenth century date, as there is a reference to a 'Robert the Clerk del Sarte' as a witness to a Leventhorp deed of that period, and that the ruins stand on a site possibly occupied by three separate consecutive churches. It is probable that the first edifice was a chantry chapel-of-ease associated with an early Thornton Hall. Of the possible three churches that stood on this site, the first would be a simple two- or three-celled building, then later, as the population and status of Thornton grew, another would be erected, at which point most, if not all of the original chapel was swept away – certainly little was preserved in the fabric of the second church, which probably followed the ground plan of the original, and nothing has survived the third rebuild in the seventeenth century.

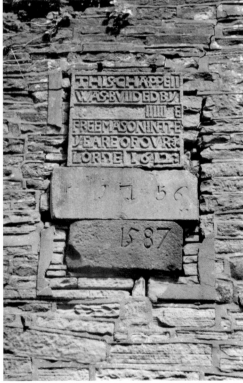

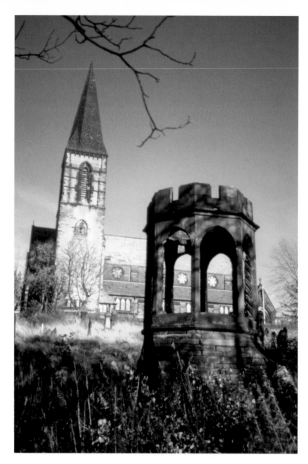

Thornton Church and New Vicarage

The site for the new church – half an acre – was given by John Foster, of Queensbury and Hornby Castle. The architects were T. H. & F. Healey, and on 26 October 1870 the foundation stone was laid by the Right Hon. Earl de Grey and Ripon, K.G. in grand Masonic style. The mallet used was also used at the laying of the foundation stone of St Paul's Cathedral. The new church, which is in the Early English style of architecture, was consecrated by the Bishop of Ripon on 21 August 1872.

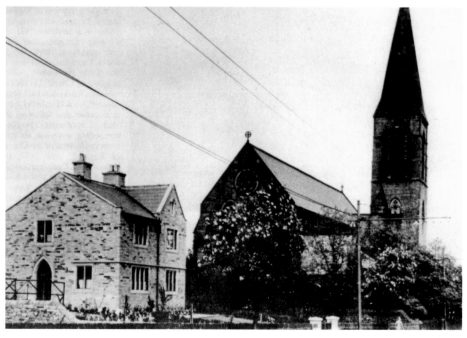

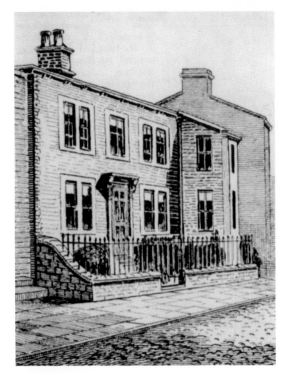

The Old Parsonage

Born of a poor Irish family on Sunday 10 August 1806, Patrick Brontë was ordained Deacon in Fulham Palace Chapel, and by October of the same year he was established in his first curacy – Wethersfield, Essex. He was ordained into the priesthood on Monday 21 December 1807, in the Chapel Royal of St James Palace, Westminster. Further clerical appointments followed before, in June 1815, Patrick Brontë moved himself, his young wife and two babies – Maria and Elizabeth – from Hartshead to this house, 74 Market Street, Thornton, seen above as it was first erected. Built in 1802 by John and Sarah Asworth, who were responsible for the erection of Clogger's Row, it stood at that time detached from other dwellings overlooking sloping fields. In Patrick Brontë's day there was a 'dining room on one side of the hall and a drawing room on the other'. The window above the doorway lit a dressing room.

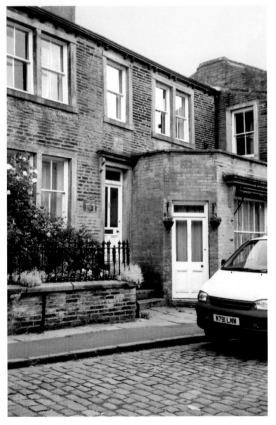

74 Market Street, a New Life

Following the Brontës' departure to Haworth, a second vicarage was built near the new church, and the 'old Parsonage' with the addition of a shop front became a butcher's. Livestock were slaughtered in a small abattoir at the back. In more modern times, when it was thought there might be a place for Thornton in the Brontë trail, it became a tea shop, but this venture came to nothing. William Scruton, a noted local historian, wrote in 1898, 'It was at Haworth that Mr Brontë's gifted children . . . achieved literary fame ... but their birth-place was here ... a fact of which the inhabitants of that village ought to feel proud. But until the spot [house] ... is rescued from the 'base uses' to which it is now put, and restored to something of its original semblance and dignity, any attempt to honour their memory ... must be regarded as incomplete'. Today it is now a private residence to a best-selling author and member of the Brontë Society and in some way has achieved the aspirations of William Scruton.

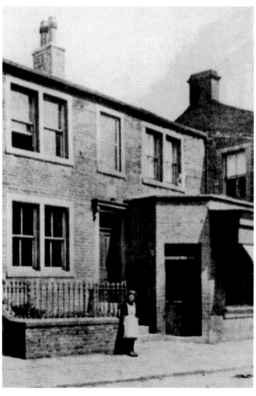

Kipping Chapel

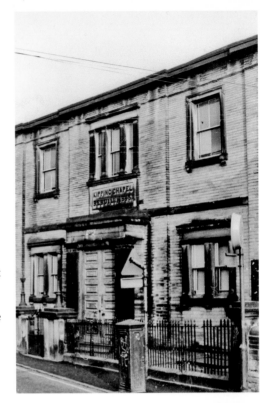

The date of the establishment of the old Independent Congregation at Kipping cannot be fixed with certainty. There is a tradition that the Kipping 'congregation' first met openly at Well Heads, above Thornton, in the days of the 'Long Parliament', called together by Charles I in 1640. However, it may date back to the days of Queen Elizabeth I, but it is recorded that following the Act of Uniformity in 1662, compelling everyone to conform to the rites of the Church of England, until 1672, the Independent Congregation met illegally, mostly in a barn down Lower Kipping Lane. This Kipping Congregational Chapel on the south side of Market Street, toward its bottom end, was built on its present site in 1769, and enlarged in 1807 and 1823; both dates marked on a plaque high up on the side elevation and was largely rebuilt in 1843, which is the date carved over the entrance.

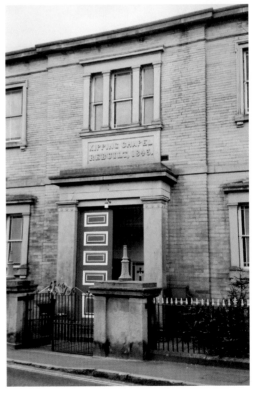

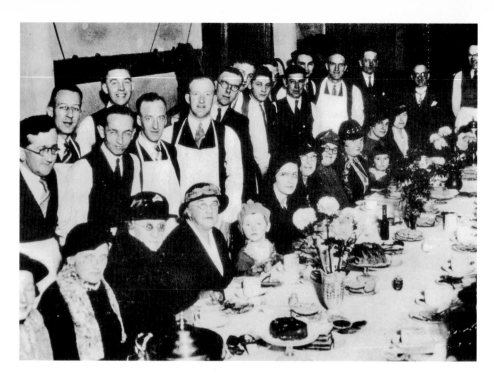

The Chapel Tea

In the nineteenth century, the chapel at Kipping had an enormous congregation and a very active social life, both for men and women separately. However, the 'Chapel Tea' was held annually, when it was the tradition for men to serve the ladies who provided the delicious fayre. Below can be seen the datestone mentioned on page 30. The photograph is taken in front of Thornton Library and Community Centre, and it can be said today, that the village still has an active and varied number of social gatherings.

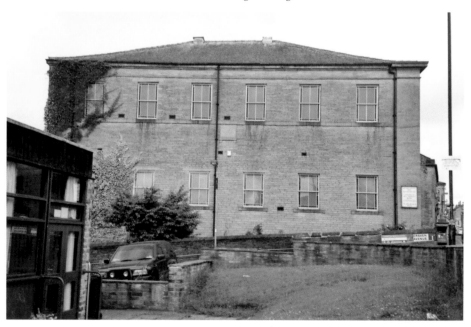

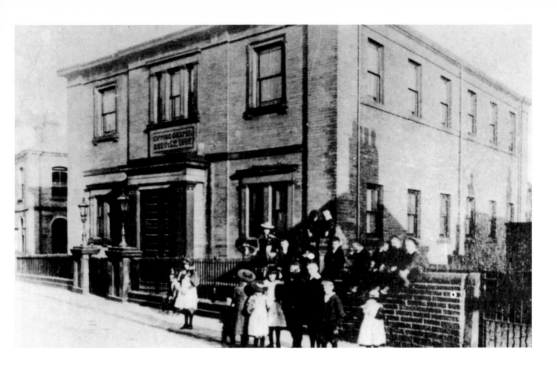

Kipping Churchyard

When I lived at Thornton in the early 1970s, the village had several churchyards, many difficult to attribute to a particular religious persuasion. However, one whose ownership could not be mistaken was that behind the Kipping Chapel, sadly now overgrown and derelict, wearing an air of desolation. There was another further up New Road and another behind a mill above the Bell Chapel churchyard. Eventually, many closed, and a municipal cemetery was created well beyond the village boundaries.

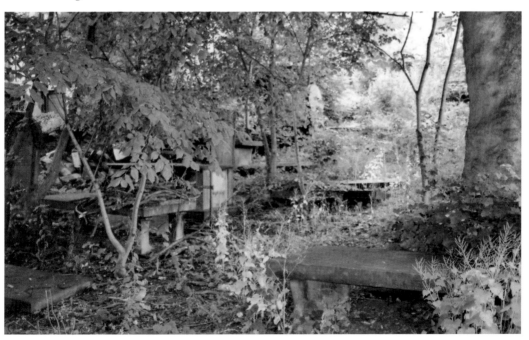

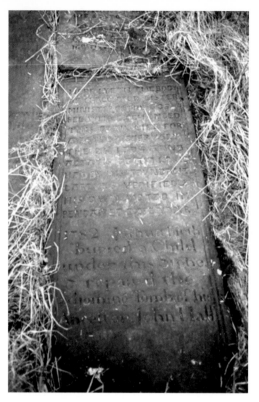

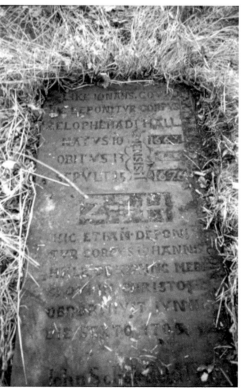

The Bell Chapel Graveyard

An interesting aspect of the old chapel graveyard is the small number of older gravestones where mention is made of the family ledger stones of 'church members' being lifted, and the corpse of a 'Chapel' member being surreptitiously interred beneath. This took place at a time when Nonconformists were persecuted and it was against the law for them to be buried in consecrated churchyards. Of this type the most interesting is that of Zelophehad Hall, son of Dr John Hall of Kipping, founder of the Kipping Chapel here. He himself died in London on 6 June 1709, at the age of seventy-eight years. His remains were brought back to Thornton and laid with those of his son Zelophehad, close by the grave of Joseph (d. 1709) and Accepted Lister (d. 1709) – more locally known as 'Little Ceppy' – in the burial ground of the Old Bell Chapel. Other stones commemorate those who died of typhoid and influenza, and there is one that records a family dispute where no one would pay for the headstone, so it was left to a poor mother to find the money.

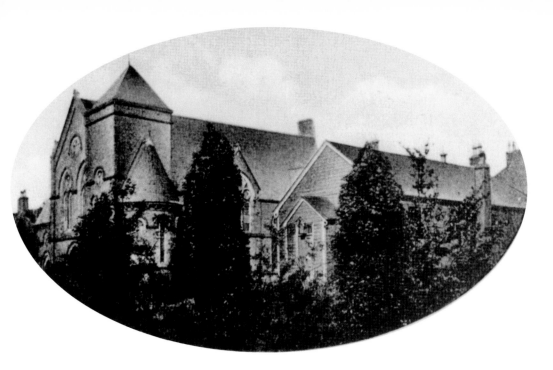

Congregational Chapel, New Road

New Road Congregational Church (*above*), an offshoot of the Kipping 'Congregation' was opened on Good Friday, 1871, and cost a total of £3,600; towards which the late Mr Craven, of Clapham Road, London, formerly of Thornton, contributed £1,000. The design was Victorian Gothic, a style that had not previously been introduced into Thornton. The New Road 'Congregation' was formed in 1866 under the pastoral care of the Revd James Gregory. In more modern times the huge building was demolished and rebuilt as sheltered housing with the chapel on the ground floor.

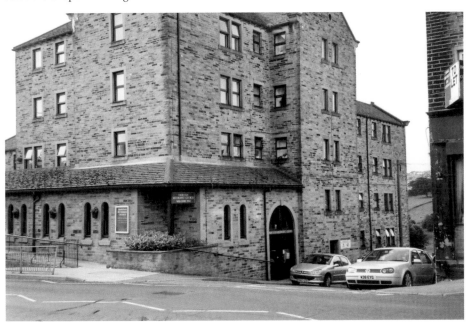

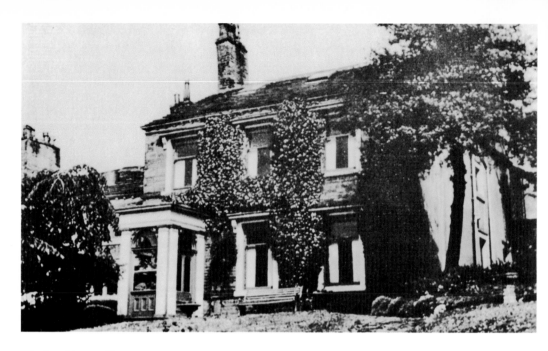

Kipping Manse, Thornton

At what date the house (*above*) behind Kipping Chapel was acquired for a 'manse' for the ministers of Kipping remains a mystery, but in the year 1866, it was then the residence of Francis Craven, a manufacturer who owned mills in Thornton and Bradford. Mr Craven then moved to Ashfield, at the top of Green Lane. A generous benefactor to the village, he provided a large donation toward the erection of the Mechanics' Institute, and then again when they were struggling he provided further assistance.

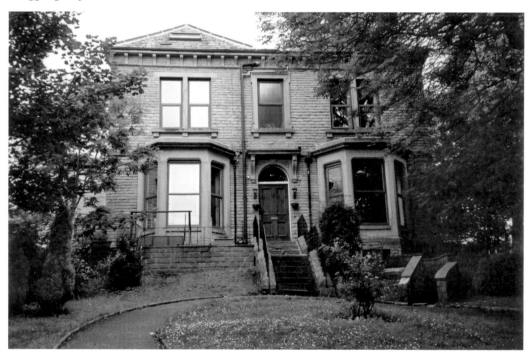

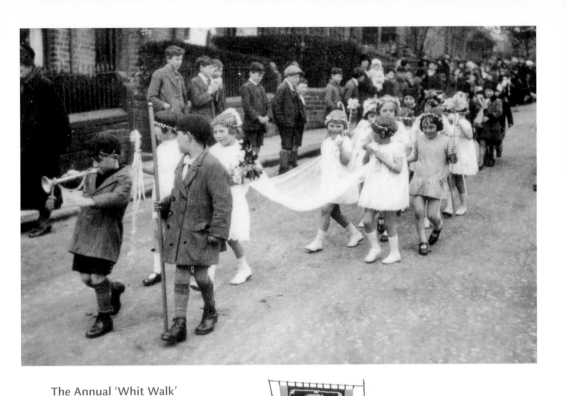

The Annual 'Whit Walk'

A highly anticipated event in the church year was the Whitsuntide Walk when the Sunday school scholars, parents and villagers would parade through the streets with church banners flowing behind the brass band who played stirring hymns such as 'Onward Christian Soldiers'. The Whit Walk was carried on throughout the county. Above are the children of Thornton on Market Street and below, the Gala Queen Judith Lyons, Revd Stanley Hawes and the Whitsuntide procession on Woodman Avenue, Bradley, near Huddersfield, in which I took part annually.

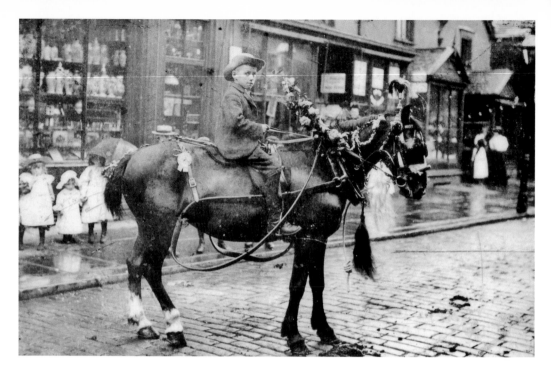

Thornton Gala

In May 1900, the Education Committee of Thornton Co-operative Society passed a resolution 'That we recommend to the Board of Directors the desirability of providing a Children's Summer Treat and Gala' – and so began an event that was for many years an outstanding feature of the village calendar. The yearly procession often consisted of six or seven hundred children, who paraded along the main streets of Thornton to the accompaniment of some noted local brass band, and decorated Co-op horse, carts and wagons; there was often a tea afterwards.

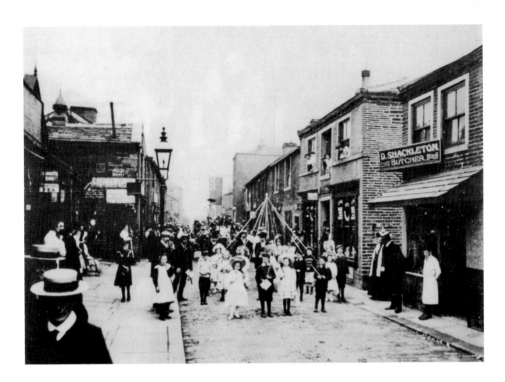

The First Thornton Gala

The first gala was thrown open to everyone, and buns and tea were provided for the children, as well as sports and prizes, in the field adjoining the farm in West Lane. Ever in the vanguard of providing village festivities under the pretext that such events were uplifting for the youth in the winter months, the Education Committee introduced a children's treat at the approach of the Christmas season, and it is recorded that, 'the organisers witnessed one of the merriest and happiest collections of youngsters that it was possible to get together'.

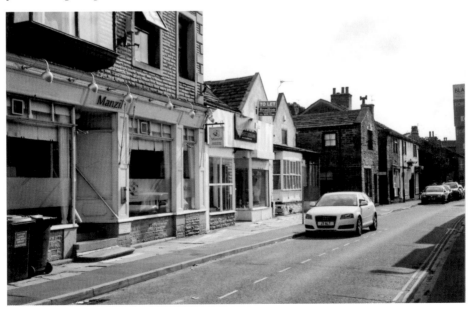

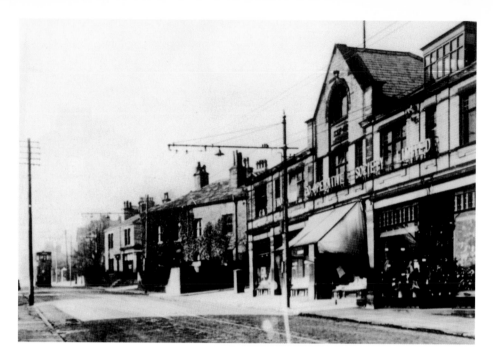

Thornton Co-operative Store

Originally part of the Queensbury Society, in 1908 it went independent. The Thornton Co-operative Society opened its doors for trading on 7 April 1909. So successful was the venture that within ten years two further branches were opened, on Market Street and Chat Hill Road, and it had to purchase a farm up West Lane to provide stabling for transportation. In 1927, to provide further accommodation for horses and carts, a fine, imposing two-storey barn was built alongside the West Lane farm and exists today as Springhall Works.

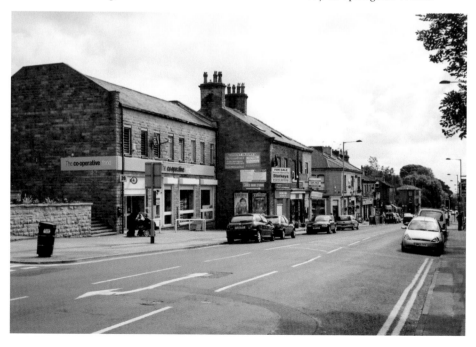

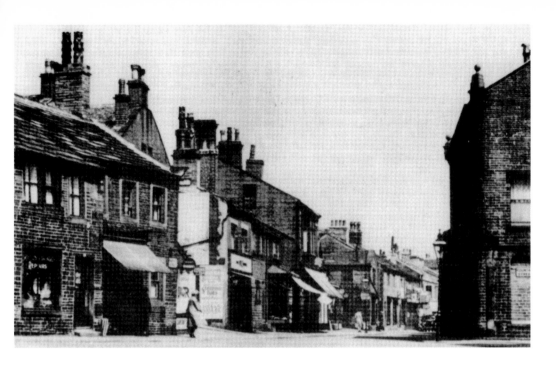

Market Street, Thornton

In 1853, the main thoroughfare in Thornton was known as Main Street or Thornton Street, and all the traffic from Bradford came along this narrow highway. It was not until the building of New Road Side, a turnpike road, that Thornton village centre was bypassed, much to its detriment in later years. Pedestrians, cars, trams and horse-and-carts all filled this roadway, and while no doubt many were thankful for the new road that allowed larger vehicles to bypass Thornton centre, many were perhaps dismayed at the subsequent loss of trade.

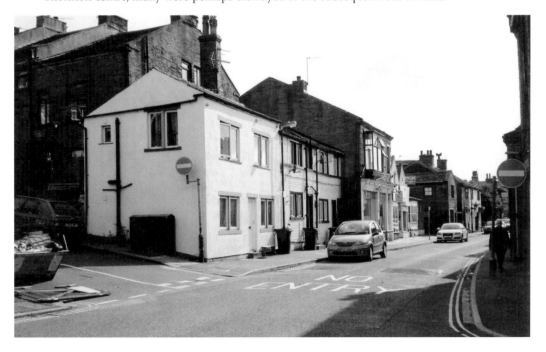

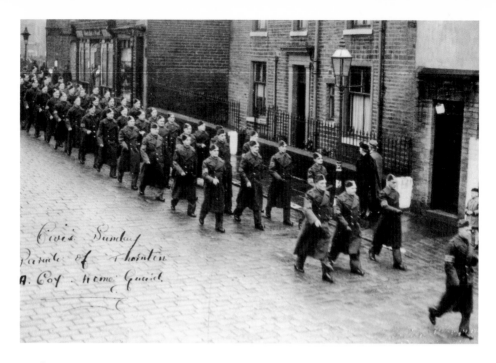

Market Street, Civic Sunday

Civic Sunday and a parade of the men of Thornton's 'A' Company Home Guard marching along Market Street. During July 1917, the penultimate year of the First World War, the scholars of Thornton Grammar School according to the school records, 'enthusiastically supported various war efforts. Two collections of eggs, fruit and cakes have been made to St Luke's Hospital [in Bradford]. 200 chaff bags [horses feeding bags] and 700 sandbags have been made, whilst there have been War Saving Certificates issued to the value of £330'.

A Show of Military Pride

Officers and cadets kitted out in First World War uniforms, but there is no identification as to who or what they represented. All that is recorded is that this photograph was taken in Thornton. The lone youth at the front appears to be in a completely different uniform, possibly the Boys' Brigade or a naval cadet. In 1918, it is recorded that the headmaster of Thornton Grammar School wished to resign to join up to fight for king and country, but before a decision could be made the war ended.

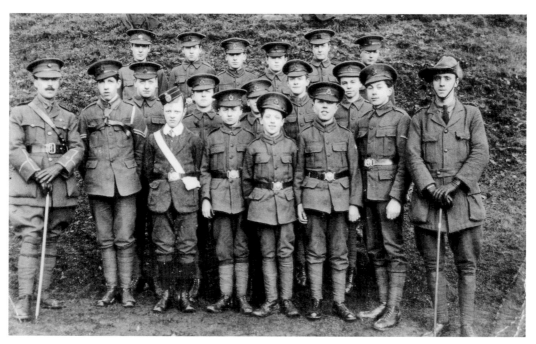

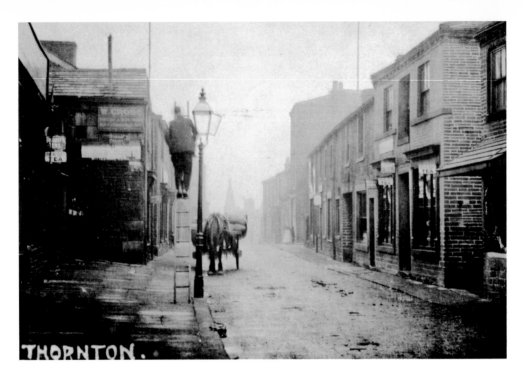

Market Street and Back Field

Incredible as it may seem, a quiet Sunday on Market Street today would present an almost identical scene – except that electricity has replaced gas, and the lamp-lighter, like so many in the twentieth century, would be redundant! Here is the old centre of Thornton; Field Court is an eighteenth-century building, as are those to the immediate left, which are seen below, all now vacant and wearing an air of dereliction as they have for twenty years to my knowledge.

Market Street, Thornton

During the years I lived at Thornton, down Green Lane, while attending Bradford College of Art, the main street was lively with all manner of goods being traded. As an isolated and self-sufficient community it was necessary to stock for every eventuality. However, I have noticed, on the occasions of going back, how the shops have gradually closed and become empty. Always a poor community, there is probably not enough money for repairs to be carried out and in July 2011 on this trip I was saddened at the dismal prospect Market Street presented.

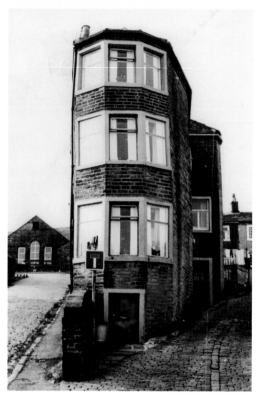

Coffin End, Market Street

The unusually shaped and named Coffin End – the group of buildings which divides Havelock Square from the approach to Thornton National School – is an interesting example of the characteristic pattern that occurred in this township, particularly on the north side of Market Street. The prevalence of small freeholds was suited to the small-scale structure of the building industry of the nineteenth century. In that century the houses and plot shapes were made to fit the boundaries of the land, hence Coffin End squeezed into a triangular plot. Often, street layouts were not co-ordinated between one estate and the next, and cul-de-sacs and remnants of old field boundary walls can be found within the village core. An interesting disorientation created by subsequent building onto individual fields is that of Havelock Square and Havelock Street, the former almost forming a cul-de-sac and the latter offset from it. Rights of way could also exercise an influence with public footpaths winding down into the village centre and skirting plot boundaries. In the nineteenth century came the introduction of yards reached from the street by means of a covered arch.

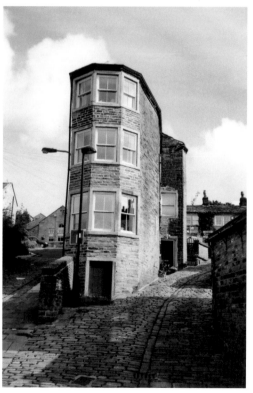

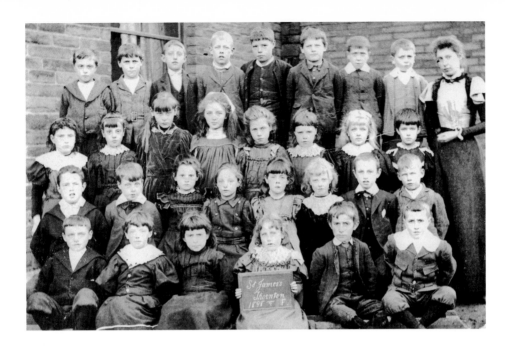

Thornton National School

Class F, St James's National School, Thornton, 1898. Headmaster William Williams: 'Writing on the whole, is pretty fair, but it would be greatly improved were more attention paid ... to the accurate formation of the letters, and ... encouraged to write more on paper. Often I find traces ... where Standard III has written accurately, and with rapidity on their slates. Writing on paper is after all the only way in which it will hereafter be useful; for whoever uses a slate out of school?'

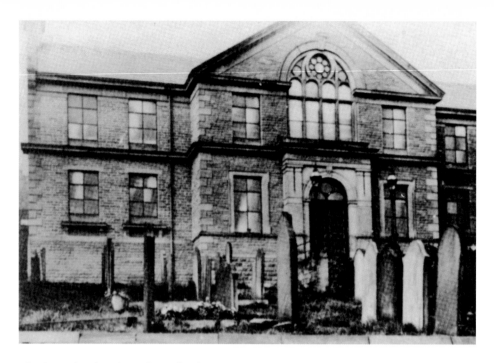

Kipping School and Sunday School

The original Kipping Sunday school was on Market Street (*below*), and the inscribed stone dated 1818 can still be seen. Later, a larger Sunday school was erected for the village children, and the Kipping 'Congregation' allowed the school to be used extensively by the Church of England Grammar School when an acute shortage of accommodation arose in the 1920s, and here the 'first-formers ' had classrooms in the 'intimate isolation of Kipping Sunday School' under the 'maternal and pastoral care of Miss Troman and Miss Irvine'.

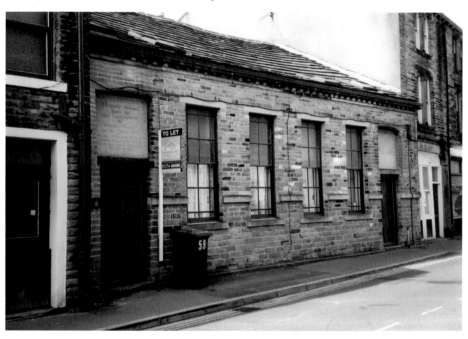

Thornton Grammar School

The original site of Thornton Grammar School was here, at School Green, on land bought in 1672 and endowed through the benefaction of four locals who gave lands and tenements in and around Bradford, the rents from which allowed the building of a small schoolroom opened in 1673. Hardly typical of late-seventeenth-century architecture, it was possibly rebuilt in 1852, dated below the chimney, but the school is clearly marked on an Enclosure Map dated 1771 and was in use until 1874. The first recorded headmaster was the Revd James Ward, 1690–1702.

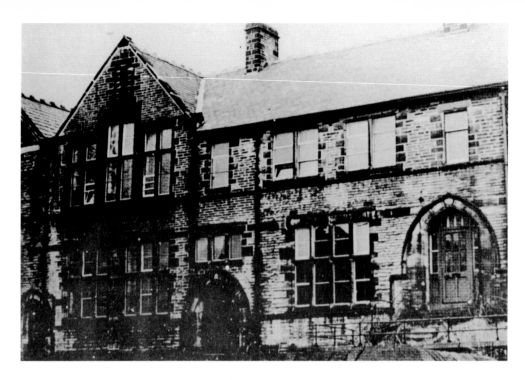

Thornton Grammar and Secondary Modern School

In 1876, a new Grammar School was erected on land adjoining Thornton Baths obtained from Joseph Craven, of Ashfield, Thornton. The architects for the school were T. H. & F. Healey of Bradford, and the building cost £2,600 including furnishings! The first Headmaster was the Revd T. Waldron who wrote in his first report, 'I opened the school on the 15th January 1877 with 27 pupils, subsequently increasing to 31. My first few days were spent in examining the character and extent of the attainment of my new pupils ...'

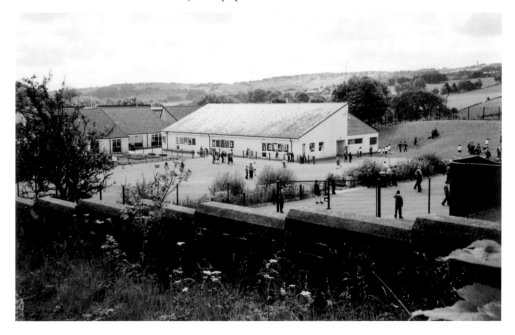

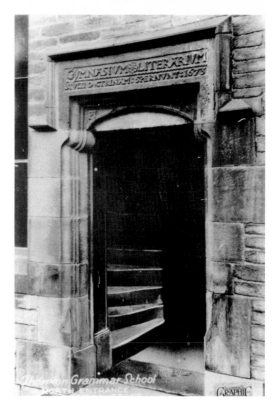

Thornton Grammar School Today

The stone entrance from the original Grammar School (*left*) was removed to the school of 1876 date, and bears the inscription '*Gymnasium Literarium Sculti Doctrinam Spemunt 1673*'; it has since disappeared. An early-twentieth-century Grammar School prospectus records 'the Chairman of Governors was Sir Theo Peel, Bart. JP. Headmaster: J. Latham, M.A. (Oxon), Ll.D (Dub), B.Mus (Lond), Dip. Ed. (Dub). Boys and Girls may enter at seven years of age. Tuition Fee, 13*s* 4*d* per Term, is due in advance and payable in full where attendance at all is made in a Term. Entrance Fee 2*s* 6*d*. Since 1898, pupils at the School have been successful at various Examinations – Oxford Senior Locals; College of Preceptors 1st Class Certificate; many Board of Education Exams; Entrance Scholarship to Bradford Grammar School; Candidates PT Entrance. Curriculum: Holy Scripture, English (including Language, Geography, History, &c.), Mathematics, French, Latin, Natural Science (with practical work), Drawing, Modelling, Needlework, Singing, Drill. Punctuality and regularity in attendance are of the highest importance, and parents are requested not to allow any deviation from this rule. School Hours: 9 to 12.15; and 2 to 4.15. Saturdays are whole holidays.'

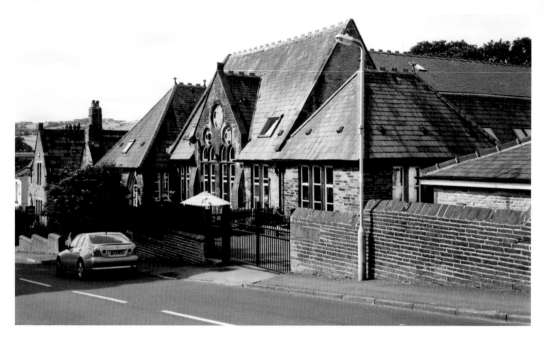

James Street Church of England School, Thornton

On the passing of the Education Act in 1870 it was felt that a School Board should be formed for Thornton, which also included the hamlet of Denholme. It was found that of the total number of 2,161 children between the ages of three and thirteen residing in the parish, only 1,211 appeared on the register of existing schools and 950 did not attend any educational establishment. The Board resolved to erect three schools: one at James Street, in Thornton, one in the centre of Denholme and the third at Keelham.

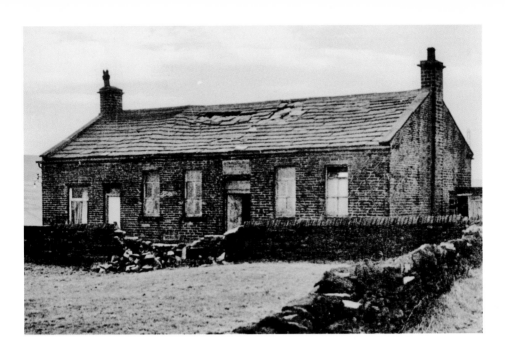

Well Heads Congregational School

'Built AD 1859' is inscribed above the door of this formerly isolated building, now gone. The abundance of water and water courses gave rise to a number of place names and the district abounds with such titles as 'Manywells', 'Well Heads', and 'Spring Holes'. Nearby Denholme is a compound of the word 'dene' and 'holm', the former meaning valley in Saxon and the latter signifying 'land enclosed by water'. In 1770, the moor and waste lands were 'walled in' giving us the landscape that is familiar to the inhabitants of today.

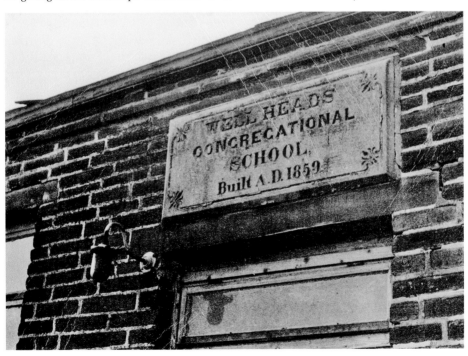

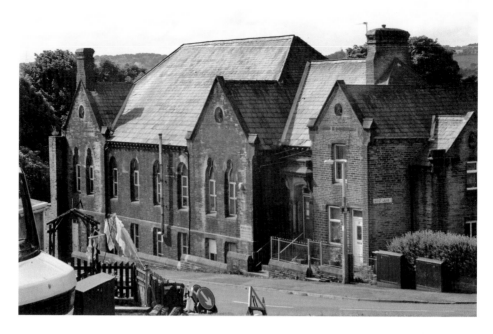

Education – A Thing of the Past?

During the nineteenth century, Thornton was well-supplied with schools and educational establishments. There were Sunday schools, Dame Schools, and the Grammar School. Today, only one survives. Members of the School Board in 1876 were: Joseph Craven; H. E. Foster; Jonathan Knowles; E. E. Rawson; William Pickles; M. Priestley and T. Bancroft Jnr. The National School on the north side of Market Street, built in 1831, was enlarged around the year 1876 by the addition of a large infants' room. In 1863, the Master of the National School was Alex Priestley.

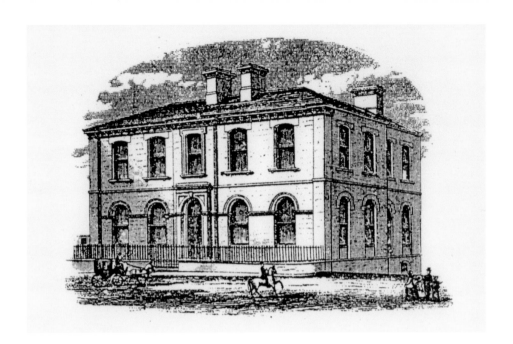

Thornton Mechanics' Institute

Thornton Mechanics' Institute was founded in 1834, just seven years after the first Mechanics' Institute in England. It first met in a house next to the Brontë Parsonage, before moving to the old Kipping school on Market Street. After only a few months it was removed into the Athenaeum Rooms in Commercial Street owned by Joseph and Frank Craven, who ran Dole Mill. Later, in 1871, the Institute moved into the purpose-built premises above and continued until 1900. A cinema was introduced in 1911 and in 1961 it was demolished.

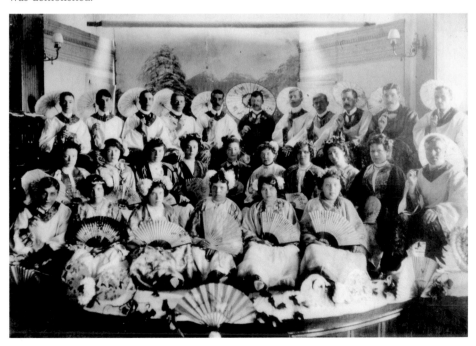

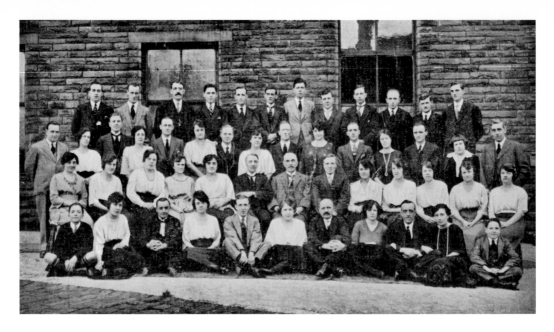

Thornton Mechanics' Institute Operatic & Drama Society

A popular aspect of the Institute's social life was the Operatic and Dramatic Society, and in October 1922 a production of Gilbert & Sullivan's comic opera *The Gondoliers* was staged. The principals in the production included Mr A. Craven, as the Duke; Mr S. Robinson, as Luiz, his attendant; Miss M. Spencer, as the Duchess; Mr & Mrs A. Clarke; Mrs Herbert Pickles; Master G. Crossland, as the Drummer Boy; and Master L. Robinson as the Page Boy. The Musical Director was Mr J. W. Horsfall and the accompanist was Mrs M. Robinson.

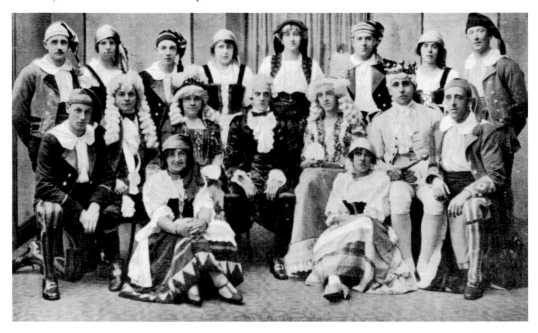

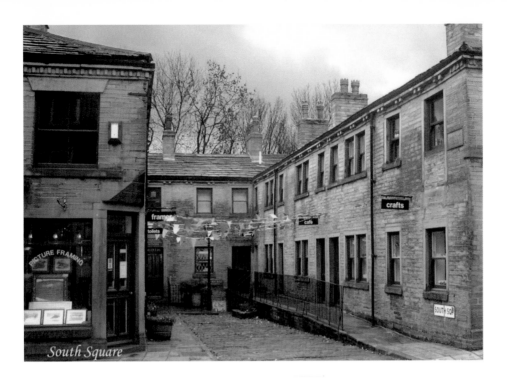

South Square, Thornton

Examples of good, nineteenth-century vernacular architecture in Thornton include South Square. This is a typical demonstration of the unco-ordinated street layouts between one estate and the next resulting in a cul-de-sac facing onto the road. South Square eventually became empty, and the community bought the entire property and turned it into an arts centre and community facility, with individual houses becoming small units for artists and a common gallery and café in the upper storey of one wing. I set up a museum about Thornton history in what is now the picture framers.

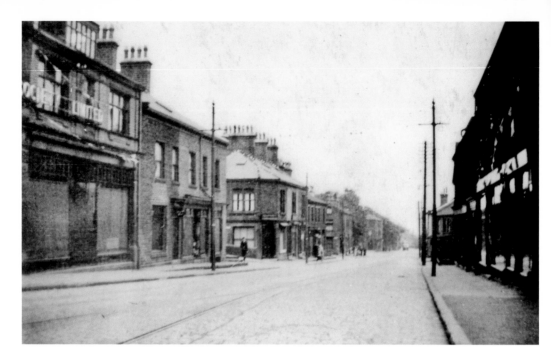

New Road Side, Thornton

The main road to Thornton from Bradford originally ran by way of Crossley Hall and Leventhorpe Mill along the present old road, and proceeded through School Green into Market Street and thence down Kipping Lane, but following a need for safer and faster communication between village and town, in 1826 a new turnpike road was built under the management of Nicholas Wilson. This bypassed Market Street, and the main shopping centre, but new shops like the Co-operative store and New Roadside Congregational Church sprang up on either side of the highway.

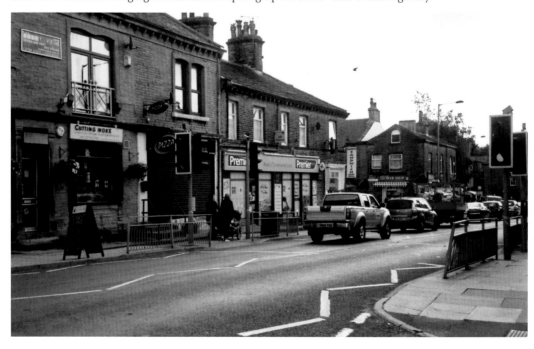

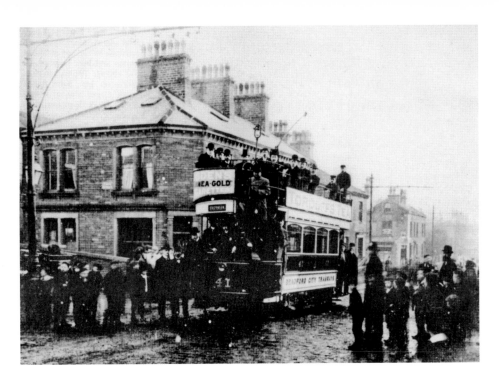

Inauguration Ceremony of the First Tram to Thornton

Trams came to Thornton in September 1882 – but it was not until 1900 that the village was finally linked with Bradford! The early route, operated by steam vehicles, ran only to Four Lane Ends – conveyance further was a matter of horse and trap or 'shanks pony'. However, from Tuesday 18 December 1900, an electric tram service was provided between Thornton centre and Four Lane Ends. The *Bradford Observer* noted, 'In Thornton there has been some agitation in favour of the adoption of a penny fare to cover the whole journey ...'

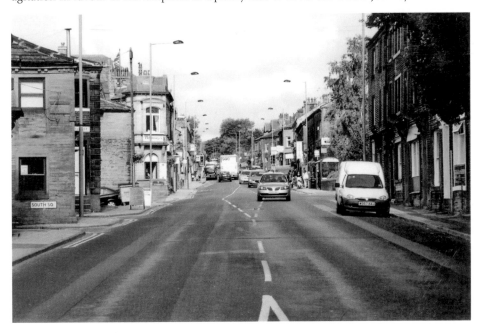

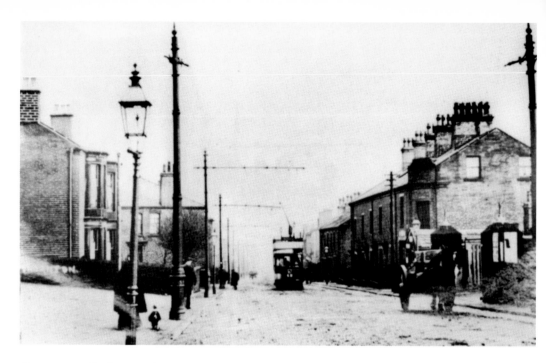

Thornton Trolleybus Service

The tram gave way to the trolleybus, and no longer was there a tram terminus outside the *Great Northern Hotel*, where a fifteen-minute service bumped and rattled passengers just over two miles to Four Lane Ends where, until 1902, a change of vehicles and an additional penny fare saw them safely into Bradford town centre. Eventually the journey became a single through route, and this made the introduction of the trolleybus possible. A renegotiation of the fares took place.

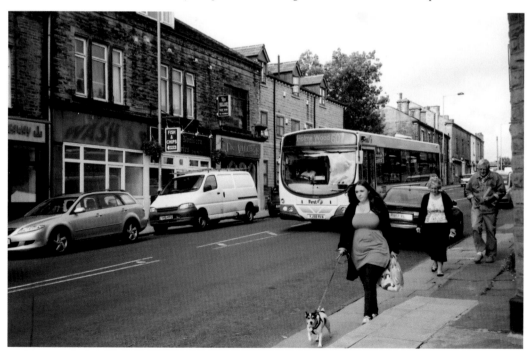

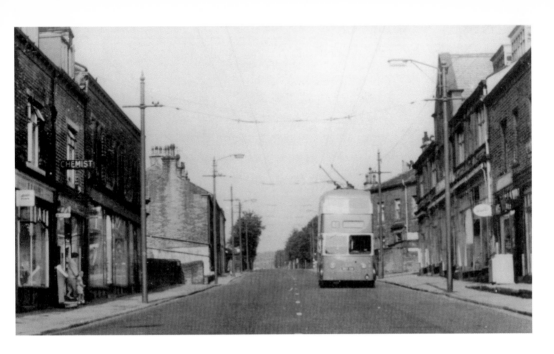

New Road, Thornton

New Road was only created in 1826 and was a turnpike road owned by the Bradford & Thornton Trust. The contractor who completed this work was Nicholas Wilkinson. The highroad from Bradford originally, after passing Crossley Hall and Leventhorpe Mill by the present main road, proceeded by way of School Green into Market Street, and thence down Kipping Lane. Being a turnpike road it was subject to tolls, and a toll house stood at Keelham (*bottom*) that still survives today, albeit hardly recognisable in its present state.

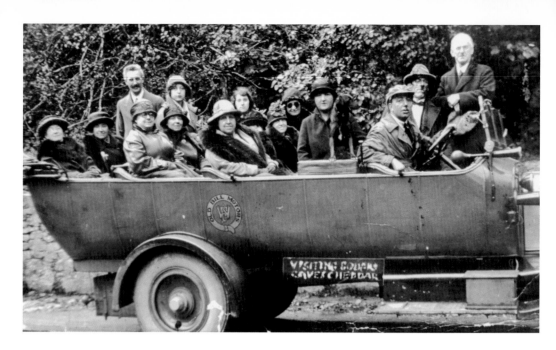

Holiday Fever

Possibly a church choir or members of the chapel setting off on a day out. The photograph below is of one trip in August 1891 to Whitby where the chapel choir went on their annual excursion. When do adults decide that they would never again be seen riding on a beach donkey? Only the boy on the left seems at ease. The mostly glum expressions of the riders vary from 'I'm quite in control, thank you' (lady on the far left) to 'I'll never do this again' (lady on the far right).

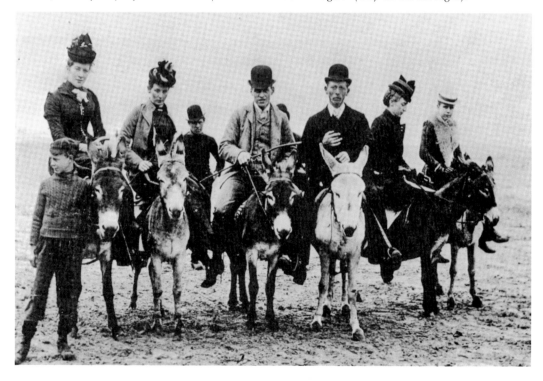

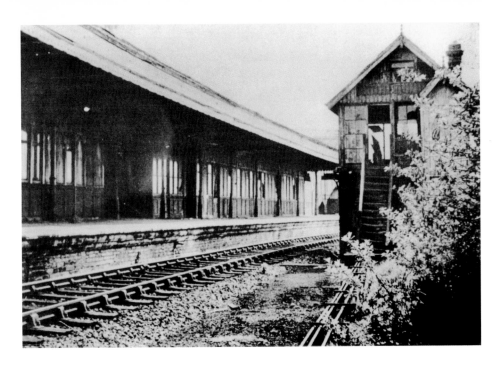

Thornton Railway Station

As early as 1863, a company was formed to promote a rail link between Halifax and Keighley up the Thornton valley; however, it was not until 1878 that a service came to Thornton – and that, four years after the first sod was cut! Contractors for the line were Messrs Benton & Woodiwiss who had worked on the highest part of the famous Settle–Carlisle line. On opening to passengers on 14 October 1878, the *Bradford Observer* hailed the event as an 'important epoch' in the history of Bradford-dale.

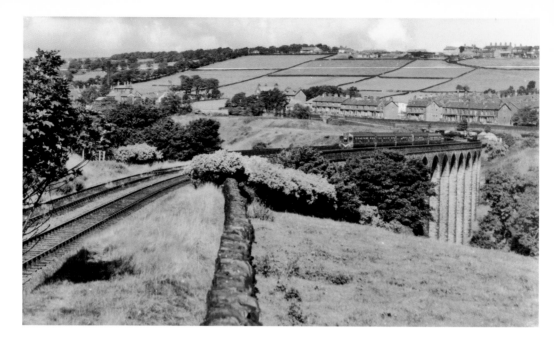

Thornton Railway Station in Bloom

By September 1964, once-proud Thornton Station, winner of the British Railways 'Best Kept Station Award' on occasions, had gone. Today the entrance to the station is marked by a sign and a well-kept floral display tended by volunteers. The Heritage Railway project was officially opened by Councillor Valerie Binney on 20 August 2009. Funded by the Councillors Ward Investment Fund and the Thornton Community Partnership, when the site was cleared, it revealed the old cobblestones. The sign was donated by Margaret Sutcliffe in memory of her brother James Allen Sutcliffe.

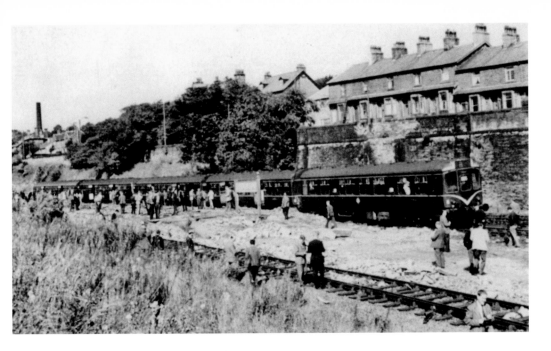

The Thornton Railway Freight Trade

Despite closure, the goods yard was still secure, and the huge stone warehouse – 130ft in length, 50ft high – and stone wharf – 538ft in length – remained for a period. Thornton's freight consisted of timber, coal and livestock transportation, and enormous pens were built to accommodate waiting animals. Thornton also formed the centre of a substantial 'maggot' industry, and large quantities left the station daily for angling shops around the country (*bottom*). Packed in wet sawdust, in special containers with air holes, it was not uncommon for thousands to escape in summer months as they sought relief from overheating!

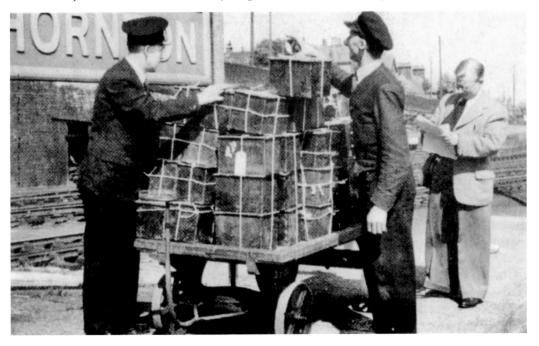

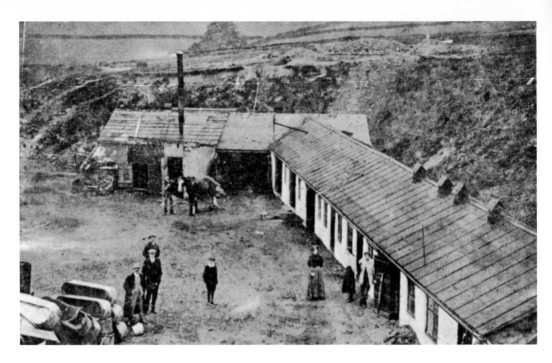

Maggotorium and Cemetery Gates

Thornton's maggot trade was run by Bryant & Company in nearby Earling's Quarry. Here, carcasses were cut up and boiled – horses slaughtered in the 'knacker's yard'. The stench produced was believed to be beneficial to consumptives so, in 1911, they conceived the idea of inviting sufferers to inhale 'the gasses given off by sitting in the same room and at the side of troughs in which the maggots are actually breeding'. Macabrely, such was the interest that the company drew up plans to build a sanatorium on the site.

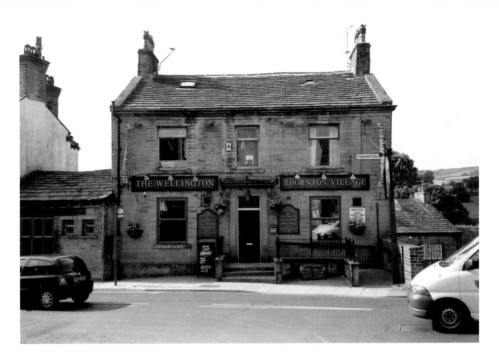

The Wellington Inn and Conservative Club, New Road

The Wellington Inn, when first opened, was one of numerous public houses around Thornton as the list of public houses and beer retailers for 1872 shows: Thomas Barker, Wellington Inn; John Barraclough, Green Mount; Joseph Bennett, Black Horse Inn; Mary Chadwick, White Horse Inn; R. Greenwood, Rock & Heifer; Matthew Haygarth, Bull's Head; Mrs. Elizabeth Jarrett, New Inn; Henry Spencer, Sportman's Inn; Joseph Thwaites, Ashfield Inn; B. Robinson & Co., Brewers at Springhead. The Conservative Club appears architecturally to date from the early 1900s.

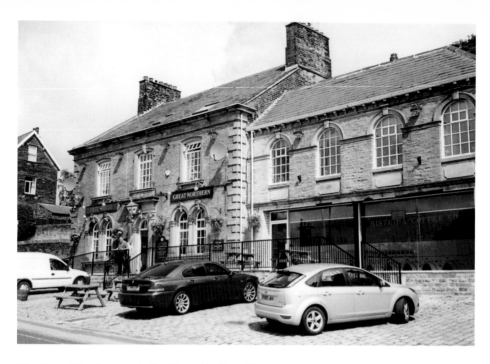

The Great Northern and the Ring o' Bells, Hill Top

Apart from public houses and inns, in 1872 there were a number of beer retailers listed: Jane Alchin, Sarah Greenwood, Sarah Hainsworth, Bell Hayes, James Mitchell, Stephen Watmuff, Thomas Stanningley, Charles Robinson, Anthony Robinson, David Oldfield, William Mitchell, Thomas Robinson and Charles Kay. The Great Northern was so called as early as 1882 and reflects that the Thornton railway line was part of the Great Northern Railway and was the nearest public house and hotel to Thornton railway station.

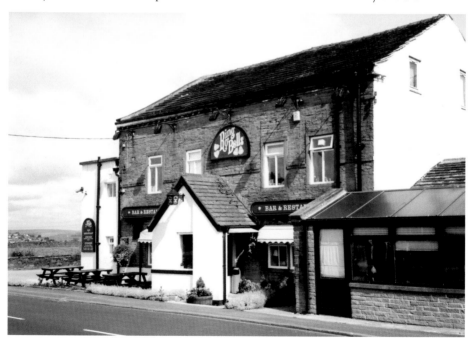

The Old Cavalry Inn, Thornton

Much of Kipping was developed on land owned by the Revd Franks and was laid out as an estate of humble workman's dwellings, which included the site for a church. The Kipping estate also encompassed the Wellington Inn on Thornton Road, and the Cavalry Inn (*above*) off Lower Kipping Lane. The Cavalry Inn was opened in 1872, although it does not appear in the directory of that year. Ever a dour exterior, it has an almost domestic appearance. Today it has totally gone and the site lies beneath the Kipping sheltered housing complex.

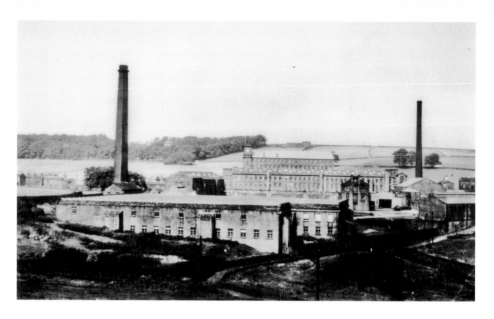

Dole Mill, Thornton

Dole Mill was built by Jonas Craven, who had a partner, Henry Harrap. Around the same time, Joshua Craven and his son, Joseph Craven, erected Prospect Mills. Later, Joseph and Frank Craven ran Dole Mill after Messrs Craven and Harrop. It is not known when Dole Mill (*above*) was erected, but a datestone over one entrance is inscribed 1887, although that probably relates to an expansion of the premises. The struggle between the domestic system of manufacture and the industrialisation of the worsted trade involved the manufacturers of Thornton in some hard times.

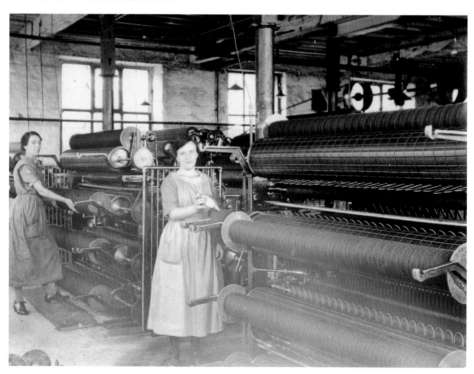

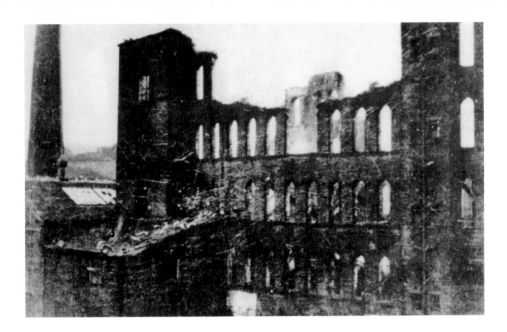

Dole Mill Fire

1837 was an especially bad year for the handloom weavers and not a few had to succumb to the inevitable. To the stronger, larger firms, however, better times soon came, with steam power and cotton warp superseding the little handlooms. In 1876, Dole Mill was in the ownership of Craven, Brailsford & Co. but by 1894 it had become the property Briggs, Priestley & Son. In 1924, a huge fire reduced the mill to a shell, but it was partly rebuilt and now lies derelict, no doubt awaiting demolition.

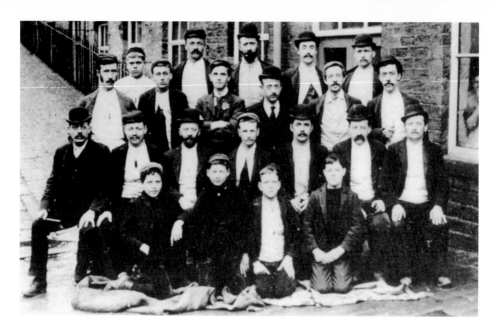

Dole Mill Employees, 1887

Around 1847 there were only two handloom weavers in the township who could earn six shillings a week, five shillings being considered a good wage. A decent cottage by comparison could then be had for two pounds per year. Interestingly, it is on record that one man who earned four shillings a week not only lived but saved money, having in his possession several shilling pieces when he died. Many of the cottages were built by the mill owners next to the mill such as Dole Street.

The Clothing Manufacturer's of Thornton

The manufacturers in Thornton between 1870 and 1880 were Craven, Brailsford & Co. of Dole Mills; Joshua Craven & Son of Prospect Mills, whose business was later purchased by Getz & Co.; Peel Brother & Co. of Thornton Mills; Northrop & Sons of Albion Mills; and R. J. Walton of Old Mill. Several of these had specialities of manufacture for which they were celebrated, namely shawls, shawl-cloth, Orleans, fancy goods, baratheas, cosbergs and Italians, and all wool goods of a special description.

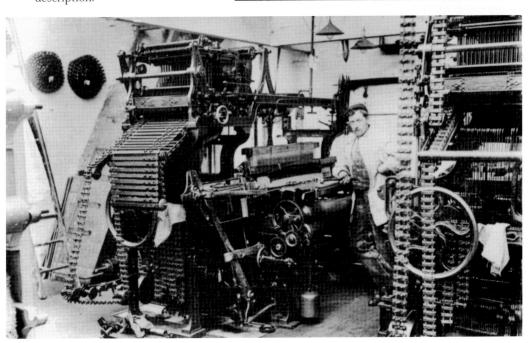

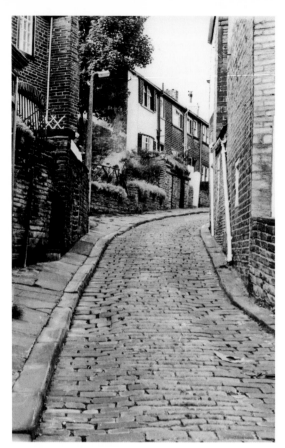

The Changing Face of Thornton

In 1800, Thornton was principally an agricultural community, but change came quickly to the village. The population in 1801 numbered 2,474; in 1851, it had risen to 8,051. By 1861 it had dropped to 7,627. This rose in the following decade to 9,142 for the entire township, while the population of Thornton alone stood at 5,687. This increase in population was mostly due to an expansion in the textile industry hereabouts, which also brought about an expansion in housing – many of which, today, are seeing a new lease of life.

The Decline of the Cloth Trade

A proud mill owner and family posed in front of a mill, which may possibly be Down Coulters Mill. In 1828, Simon Townend introduced into Wright's Mill the first power looms in the Thornton valley. Unfortunately, the inhabitants took against him for this so that he was obliged to get his first weavers from Lancashire. In 1837, he built Upper Mill, where Down Coulters stood, and greatly extended this branch. Below, the Close Head Mill of Joseph Craven Snr. By the start of the twentieth century all the mills had finished in Thornton.

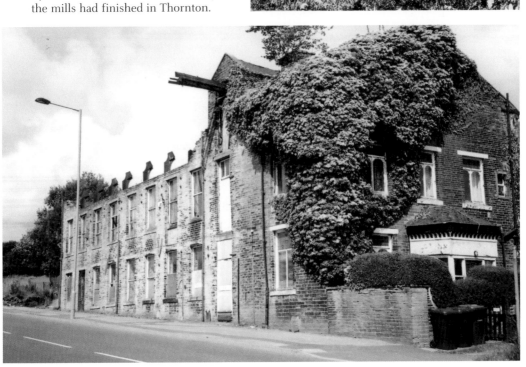

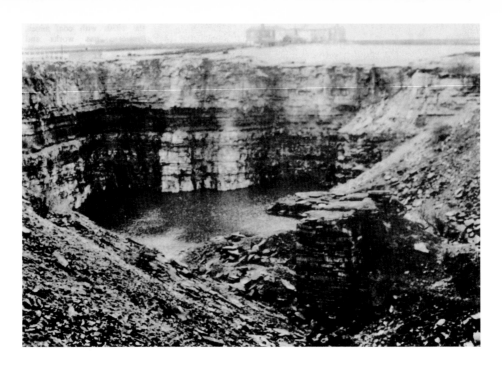

Egypt Quarry, Thornton

The stone trade was an important industry in Thornton, and the sandstone found in large quantities around the district was held in great esteem for general building purposes. The original quarries, many founded in the eighteenth century, were only small, and known locally as 'delfts' – Delft Hole being a common place name – but by the nineteenth century, large commercial quarrying had been established, their huge holes scarring the countryside. Today, many have been filled and grassed over, softening the landscape, and now wind farms disfigure the moor tops.

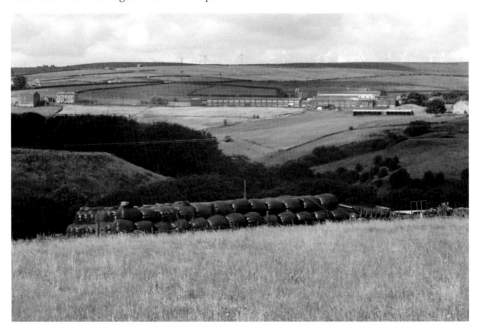

The Walls of Jericho

A product of the large-scale quarrying was the vast amounts of waste that had to be disposed of. One way was to construct huge, high walls, like the 'Walls of Jericho' and back-fill with detritus. This, a listed monument, has now gone to the shame of the local planning authorities that stood back and let it happen despite popular support for their retention and supposedly listed protection, but a number of smaller examples remain. In the 1870s, as many as thirty quarries were recorded in the Thornton Local Board district.

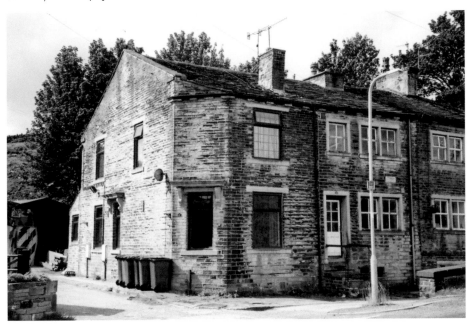

Moscow, Paris and World's End

During the heyday of the stone industry numerous small communities sprang up on the periphery of Thornton. Often isolated, they acquired curious names, many a reflection of the harsh conditions in which men lived and worked, one such was Moscow, there was Egypt and, at the foot of the Walls of Jericho, Paris and World's End, which in winter, I am sure the inhabitants thought it was. In the parish registers it is recorded that on 5 October 1757 Thomas Horsfall, a miner, was killed in a slate quarry upon Thornton Moor.

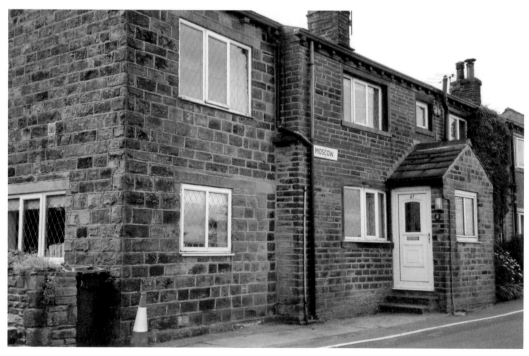

The Squatter's Cottage

A curious relic from the stone industry – a squatter's cottage erected on common or waste land. The men who built these illegal dwellings were occasionally mentioned in manorial court records. One such entry, dated 1775, records that Ake Akroyd enclosed 'half an acre' of land in Thornton. His cottage, above, in Half Acre Road, is today restored and has gained legality. Other road names in the district are Ten Yards Lane and Rock Lane, in which stands the Rock & Heifer Inn recalling the joint occupations of the area.

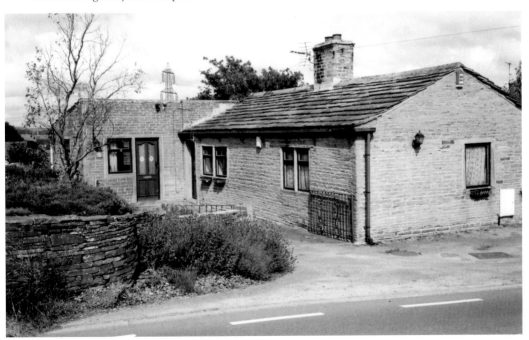

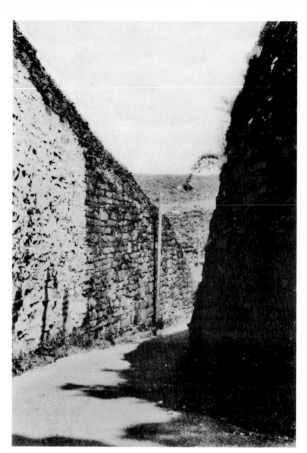

The Walls of Jericho

Much of the enormous amounts of waste produced in the quarrying of stone and slate and, indeed, from sinking coal shafts, was piled up and back-filled, and the most spectacular example of this system was demonstrated in the construction of the 'Walls of Jericho'. However, good quality stone was often sent to the old Stone Mill to be ground into chips for use in road mending and foundation construction. The mill may have been wind-powered and a drawing survives in the sketchbook of Anne Brontë.

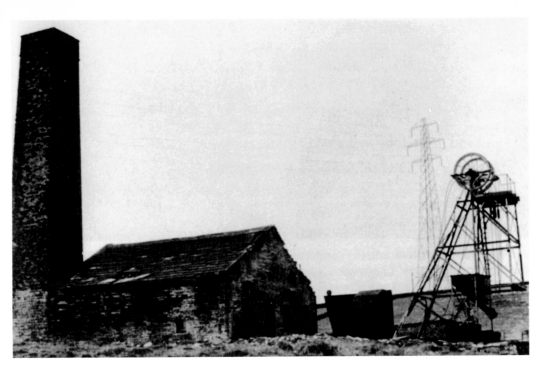

The Coal and Fireclay Industry

In 1786, William Tideswell 'fell into a coal pit and was taken out dead with his body mangled'. Coal mining was a major industry of the district. In 1704, John Dobson, Squire York and Widow Cawboard, owned mines in Thornton, but by 1876 it was noted that the coal measures were 'well nigh exhausted'. The origins of coal mining can be traced back to the seventeenth century. There was also a fireclay manufacturer whose site can be seen marring the hillside in the view below.

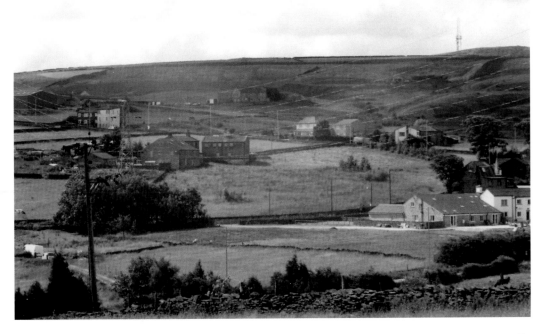

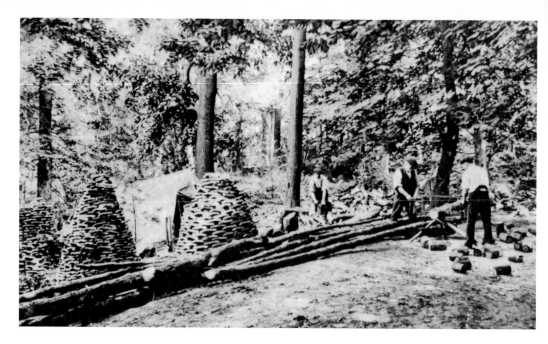

Clogger's Row, Thornton

Toward one end of Market Street can be found Clogger's Row, dated 1806; the datestone with initials shows that they were built for John and Sarah Ashworth who owned many properties in the village including the Parsonage House, home of the Brontës. Undoubtedly, the name of this terrace came from the occupation of many of its tenants. Clogs were the main footwear in the North at this date and the cutting and stacking clog soles in a local wood ready to sell to the clog makers was an industry in itself.

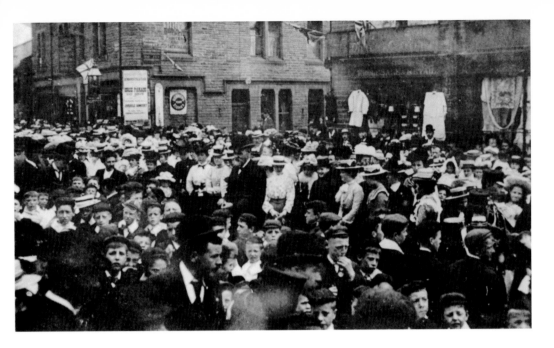

Springfield Public House

The Springfield at the top of Green Lane carries the date 1881; however, this may allude to the extension only as the larger part appears of earlier date. The inn took its name from the number of springs in the area. Drinking was both the pleasure and scourge of the nineteenth century, brought on by the fact that it was healthier to drink beer than water. It was only during the 1930s that a proper water supply came to the village; before that hand-pumped wells and springs were the only source.

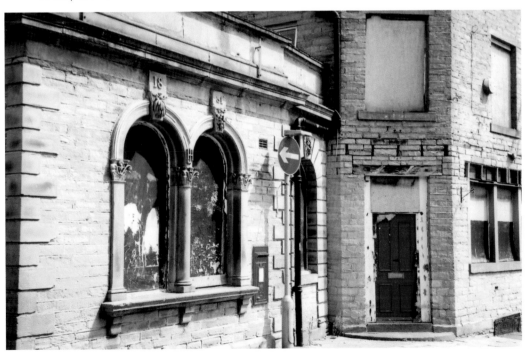

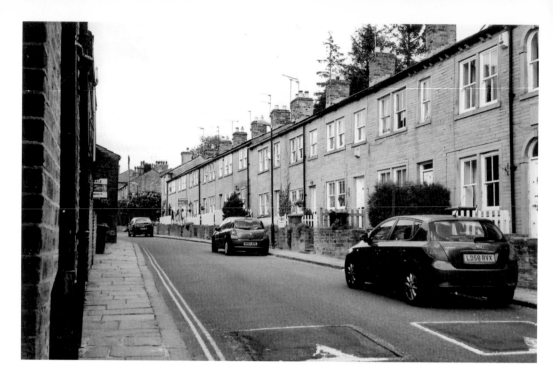

Clogger's Row and Long Row

A view along Clogger's Row, which is nearly as long as Long Row at Hill Top, seen below. With the rise in population came a need for more and cheaper housing. It was in the late nineteenth century that the terrace became the dominant architectural feature of Thornton. In the towns, schemes of terrace housing covered miles and became the archetypical image of 'Northernism'. In Thornton, the pattern of terrace housing is random and tends to follow the older system of tofts of the medieval period.

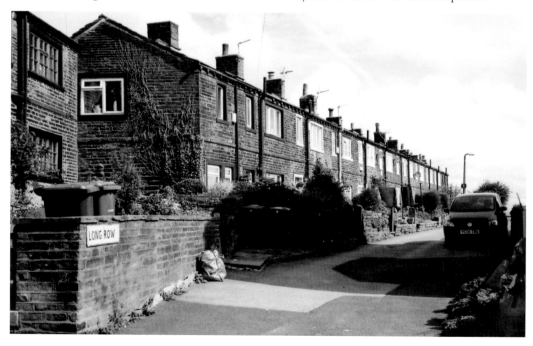

Modern Land Development in Thornton
With land becoming a premium in the twentieth century for building purposes, and as many of the older graveyards have fallen into disuse for varied reasons, a number have been declared redundant, and have become building plots. After carefully removing the headstones, and often the bodies, to new locations or disposal in crematoriums, this old Methodist graveyard in Thornton has become the site of sheltered accommodation and a medical centre in the twenty-first century, which will no doubt benefit the community for some considerable time.

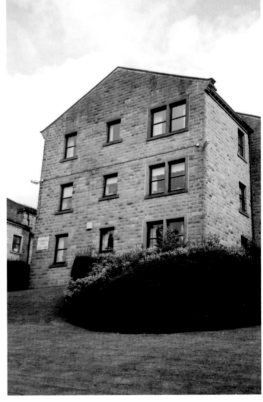

The Highways and Byways

Between the villages and hamlets of the district ran the pack horse trails, which, in the sixteenth century linked the manor houses of the area. The majority of nineteenth- and twentieth-century roads hereabouts have followed the line of these old routes. Unfortunately, the pack-horse routes were not always the easiest routes. They avoided the wet valley bottoms and inevitably exploited the shortest route between settlements, ignoring the contours of the landscape. Such planning was due to the need to travel quickly from place to place. In consequence, the most direct route was often chosen rather than the easiest but more time-consuming way. One consequence of following the old routes today is that present-day roads are often unsuitable for modern traffic and, as they have fallen into decline, they have often become pleasant semi-rural pedestrian ways, and the district abounds with public footpaths, even in the heart of Thornton. Later, roads began to develop from pack routes and as the demand for building stone grew, hamlets sprang up near the quarries north of Thornton village and the trails to these districts were widened to take the stone carts.

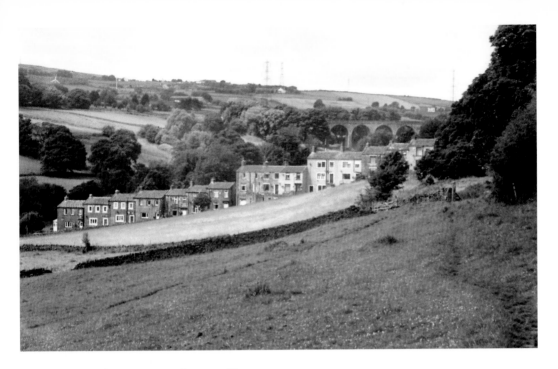

Thornton Water-Powered Corn Mill

Mr Leyland (author of *The Brontë Family*) wrote 'Thornton is beautifully situated on the northern slope of a valley, with green and fertile pastures spreading over the adjacent hills; and wooded dells with shady walks beautify and enrich the district'. Certainly this is true of the Pinchbeck Valley and it was in the lower reaches of this valley that the ancient corn mill of Thornton stood and along the beck traces of the mill-race can still be found. Work on demolition was begun in September 1949.

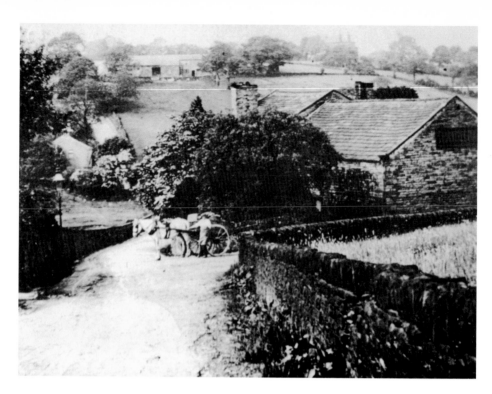

Chat Hill Lane, Thornton

The agricultural aspect of Thornton persisted well into the twentieth century. The last working farm was on Market Street, which I remember in the 1970s. At that time it was not uncommon to follow the line of cows being brought home for milking, and as a consequence, the street roundabout was often fouled with cow dung. Today, I notice the farm has been beautified and the 'Licensed Slaughterhouse No. 2' has become a residence. Chat Hall, above, takes its title from a surname, but whose is now lost in the mists of time.

Hoyle Ing and School Green

Hoyle Ing is a hamlet within Thornton and there is a house here dated 1588, bearing the initials TL and EL. These possibly refer to the Leventhorp family, or of some predecessor of the Toby Lawe. Hoyle Ing is first documented in the local court rolls under the year 1595, when it is recorded that Tristam Bolling, of Bolling (*d.* 1502) in his will, made over to John Tempest, son of Richard Tempest, part of a tenement called Rowle, and a house in Thornton 'newly built in ye holeyeng, of William Feder'.

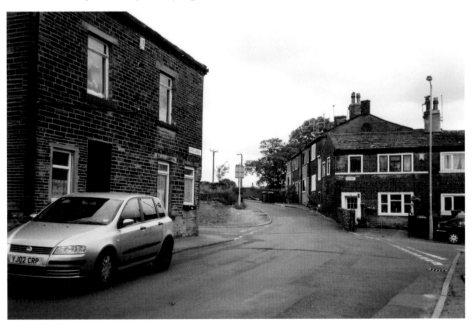

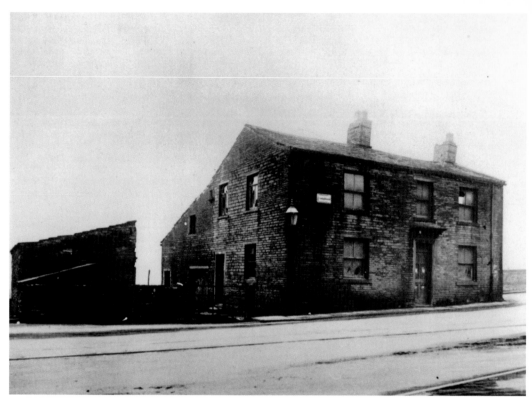

School Green and Old Grammar School
School Green is a part of Thornton and consisted only a handful of dwellings, the Grammar School and a farm or two standing by the crossroads of the lane to Allerton, which ran down then up past *Allerton Hall*, built in 1777 by the Firth family. John Firth founded a bank from which he issued his own monetary drafts known as 'Firth Notes'. On an old road from Bradford here, an ancient signpost survives carrying the date 1777, though defaced during the Second World War to prevent 'Gerry' knowing his whereabouts!

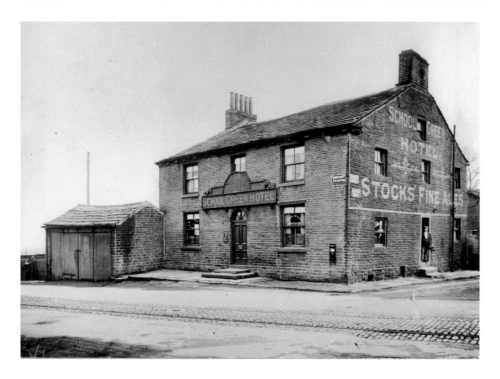

School Green Hotel

Originally a farm, sometime during the 1880s it was remodelled and became the School Green Hotel, one of numerous around Thornton as the list of public houses and beer retailers for 1872 shows. At that date there were a total of ten, including a brewery at Springhead, and thirteen licensed beer sellers. A decade or two later in the 1920s, the old property was entirely demolished and a new School Green Hotel arose. At this time, a new electrical substation was erected, behind what in modern times became a pizzeria.

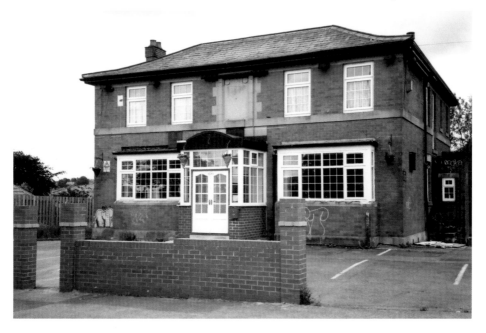

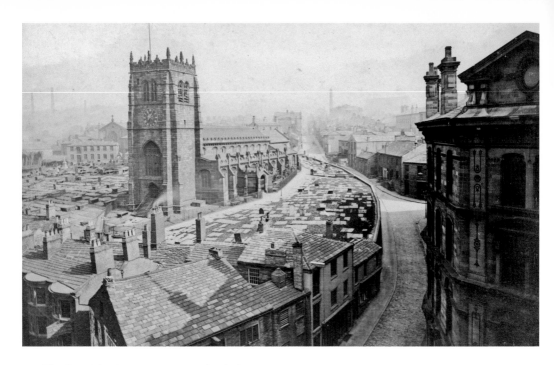

Bradford Parish Church, Now a Cathedral

The Revd Patrick Brontë and family would have been familiar with Bradford parish church, as it was the mother church to St James's at Thornton. Of Saxon origin, apart from the obvious modern additions today, the majority of work is fifteenth century. Rebuilt, the most arresting feature is the west tower, completed in 1508. During the Civil War, the church was laid siege and the defenders hung wool sacks from the tower walls to protect it from Royalist cannon-fire. The church became a cathedral in 1919.

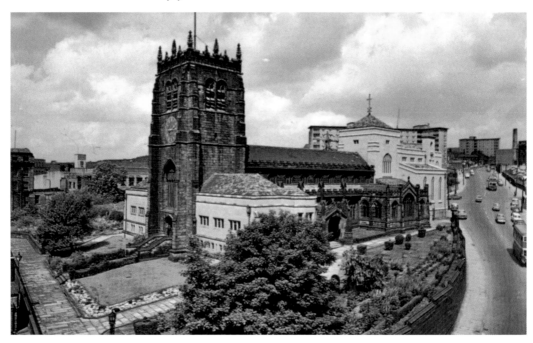

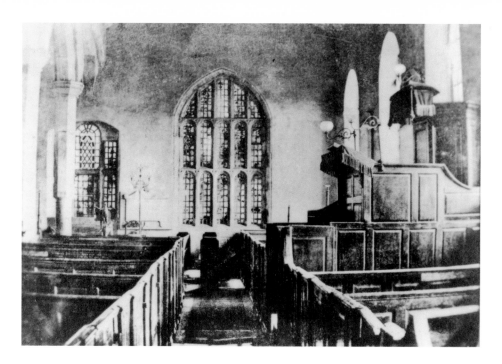

Haworth, St Michael's Church

The church of St Michael below would not be recognised today by the Brontë family; it is built on an entirely different plan to the old church above. Nevertheless, Haworth and the church is a place of pilgrimage for all Brontë-lovers, for the Revd Patrick Brontë was the incumbent here from 1820 to 1861. A brass plate near the chancel screen marks the site of the Brontë vault, and a marble tablet in the Brontë Chapel records the names of all the Brontë family, but Anne was buried alone at Scarborough where she died.

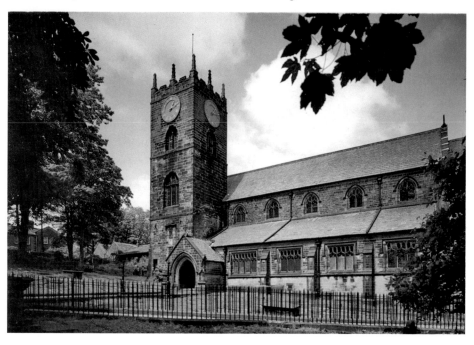

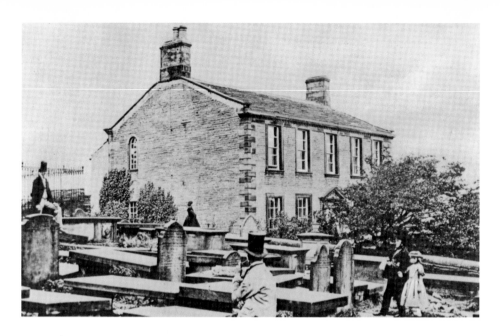

Haworth Parsonage

In the parsonage at Haworth, which stands across the graveyard from the church, lived the Brontës: son Branwell, along with Charlotte, Emily and Anne, the literary sisters who wrote some of the finest works in English literature, inspired by the surrounding moors. However, people tend to forget that these four were actually born in Thornton, some miles away, in a small terrace house on the main street of the village, where their father was incumbent for five years from 1815 before he made his last move to Haworth.

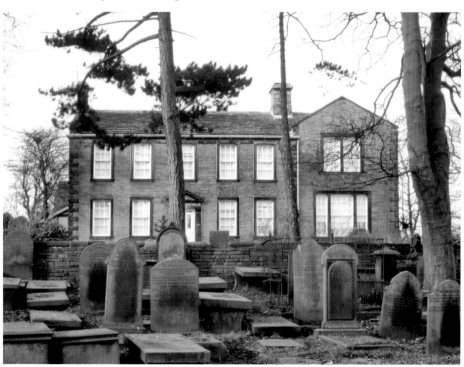

Stanbury Chapel, near Haworth

In a district so beloved by the
Brontës, stands the tiny hamlet of
Stanbury, not far from Haworth.
Here, beside the main highway, in
the midst of this small community
is a Mission chapel within which
can be found the pulpit from old
St Michael's, Haworth. This pulpit
served Haworth for years, and was
removed to languish in a nearby
farmer's barn before being placed in
the chapel. At Stanbury lived Jonas
Bradley (1859–1943), schoolmaster,
and an acknowledged authority on
the Brontë family, who founded the
Brontë Society in the year 1893.

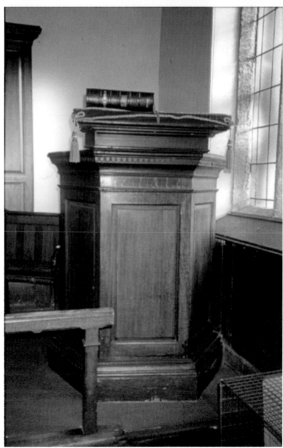

95

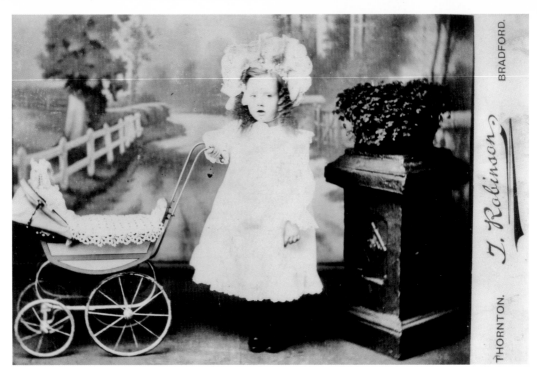

The Thornton Photographer
J. Robinson

All dressed up and nowhere to go, a lovely portrait photograph of a young, unnamed Thornton lass posing in the studio of J. Robinson, on Market Street, Thornton, sometime in the 1890s. Below, my daughter Susanna, born in Thornton, posing on a pile of rubble at the back of the White Bear Inn, down the Leeds Road near Bradford city centre, when the public house was closed and awaiting demolition in June 1985. Susi would have been about the same age as the young charmer above.

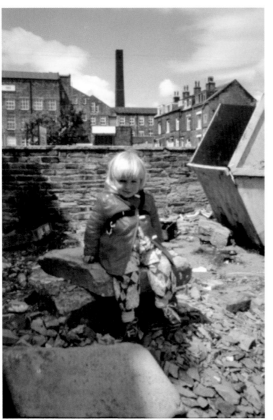